YANKEE STADIUM

1923–2008

YANKEE STADIUM
1923–2008

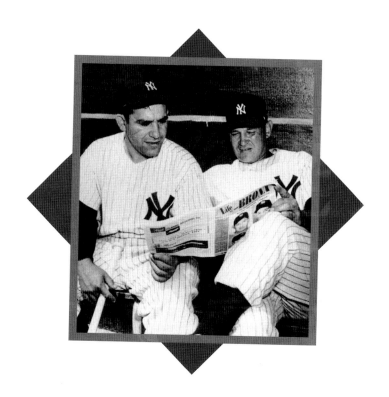

Gary Hermalyn and Anthony C. Greene

ARCADIA
PUBLISHING

Copyright © 2009 by Gary Hermalyn and Anthony C. Greene
ISBN 978-0-7385-6596-5

Published by Arcadia Publishing
Charleston SC, Chicago IL, Portsmouth NH, San Francisco CA

Printed in the United States of America

Library of Congress Control Number: 2009921914

For all general information contact Arcadia Publishing at:
Telephone 843-853-2070
Fax 843-853-0044
E-mail sales@arcadiapublishing.com
For customer service and orders:
Toll-Free 1-888-313-2665

Visit us on the Internet at www.arcadiapublishing.com

This work is dedicated to those long-passed Negro League ballplayers who never got a chance to pitch to Babe Ruth or play the Yankees in Yankee Stadium.

CONTENTS

ACKNOWLEDGMENTS

The authors would like to thank James J. Houlihan, Arne "Buddy" Weiss, Margaret Beirne, and Joshua Amata for their generosity. We also thank the staff of the Bronx County Historical Society, especially curator Kathleen McAuley, librarian Laura Tosi, and education assistant Zach Hudson, for their assistance. Finally, our gratitude is extended to Tiffany Frary and the staff at Arcadia Publishing.

INTRODUCTION

Yankee Stadium has never been just another ballpark. From its grand opening on April 18, 1923, the stadium was meant to be something larger and more majestic than any of its predecessors, especially the rival Polo Grounds just across the Harlem River. It was meant to symbolize the great city it represented, the upper crust of fans it would attract, and the largess of its very wealthy owners. At a time when baseball was in the infancy of its popularity, owners Jacob Ruppert and Tillinghast L'Hommedieu "Cap" Huston took a Roaring Twenties–size gamble on a swamp in the Bronx, choosing it to be the new home of their only recently successful ball club. Little did they know it would become the greatest and most famous sports arena since the Roman Colosseum.

Yankee Stadium was constructed on roughly 12 acres of landfill over a tidal stream called Cromwell's Creek (named after an old Bronx family that had a farm in the area). To the west was the Highbridge neighborhood whose bluffs ran from the foot of Anderson Avenue and 162nd Street all the way to the majestic High Bridge (built in 1848) that served as a grand footbridge and a landmark for weekend visitors who sailed up the Harlem River. More importantly, it was the vital connection for the Croton Aqueduct system, the first to bring a freshwater system to New York City. Next to the bridge stood Victorian houses of wealthy Bronxites, including William B. Ogden, the first mayor of Chicago. Along the Harlem River, at the foot of the hill, stood the town of Highbridgeville, an Irish and African American village that was home to the original builders of the High Bridge as well as men who made their living working for the railroad and fishing in the salty waters surrounding New York City. It was a blue-collar community, known for its train station, saloons, and tough characters.

To the east one found newly planned streets and sewers, a large train yard, and the rocky hills that would be flattened to make way for urbanization. Although the borough's business center was located roughly 20 blocks south, it was obvious that the center of all business and government would eventually work its way northward.

The Bronx investment was risky but was well thought out. As New York City expanded and grew, the Bronx was in the midst of a 100-year evolution that transformed it from an early-19th-century collection of small villages and farms to a mid- to late-19th-century industrial center to an early-20th-century residential borough. Urban planners laid streets on top of farms, old dirt roads became paved streets, and rapid transit was built to connect the metropolis to its only link to the North American continent. Sporting was no stranger to Bronxites and wealthy sports fans as they flocked to horse races at the Jerome Park Racetrack and the Morris Park Racecourse to watch the first running of the Belmont Stakes and to baseball games of one of the first professional teams, the Union Baseball Club of Morrisania, which featured two of the sport's first professional players who would eventually play for the Cincinnati Reds. These original Bronx Bombers were locals, possibly working as brewers, factory workers, or

municipal employees. The Fordham University Nine played games at the Rose Hill Campus, inviting barnstormers, professional teams, and college rivals like Harvard and Yale to partake in well-attended games. The Interborough Rapid Transit Company built subways that connected the borough to Manhattan's Lexington Avenue line, raising it aboveground after 149th Street and becoming an elevated train to its final stop, the famous Woodlawn Cemetery. In 1909, the Grand Boulevard and Concourse, a signature and elegant thoroughfare much like the Parisian Champs-Elysées, was completed, bringing the Bronx's, and possibly the world's, greatest concentration of art deco and art moderne apartment houses. Many of the concourse's buildings came complete with doormen, elevators, outdoor courtyards and gardens, sunken living rooms, and large apartments. At the foot of the great boulevard at 161st Street stood the Concourse Plaza Hotel (built in October 1923), an extravagant structure that was the borough's first and only luxury hotel and provided yet another example of the wealth and largess of the Roaring Twenties. It is no coincidence that this hotel would open only months after the great stadium was completed.

When the New York Yankees moved into the new stadium, the course of baseball history would forever change. Appropriately, the Yankees beat the rival Boston Red Sox 4-1 on the strength of former Red Sox George Herman "Babe" Ruth's three-run home run, the first to be hit in the stadium. Also, it should be no surprise that the Yankees would later beat their bitter rivals and former landlord, the New York Giants, in the World Series to capture their first title.

The Yankees' success has mirrored the rise, fall, and resurrection of the Bronx. The Yankees have evolved into a worldwide brand, just like the Bronx has become a new home for immigrants and people from around the world seeking a new beginning and better life for their families. The construction and opening of the new Yankee Stadium marks yet another chapter in this story, one rooted in hope, ambition, and success.

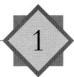

THE EARLY DAYS

The Yankees' move to the Bronx proved to be very successful as they captured the first of 26 World Series titles while playing at 161st Street and River Avenue. In addition, the team enjoyed the love and admiration that success in New York brings, as their fan base grew in line with their reputation as baseball's gold standard of success.

Owner Jacob Ruppert's dream of building the world's greatest sports arena was realized as upgrades throughout the 1920s increased seating and attracted larger crowds. Yankee Stadium soon became a prime sporting venue, attracting large crowds for football and boxing. It became one of the Bronx's most important and notable buildings in addition to the luxury Concourse Plaza Hotel and later the Bronx County Courthouse. These three buildings, all located on the 161st Street corridor, comprised the political and social center of the borough. In addition, only a short walk east was the Grand Boulevard and Concourse. Its luxury apartment buildings housed some of the borough's most wealthy and accomplished residents who lived in art deco and art moderne buildings, complete with doormen, sunken living rooms, high ceilings, elevators, and courtyards.

The early Yankees teams, as well as early Bronx development, helped lay a foundation that future success would be built upon. The original formula was a mixture of forward-thinking owners, great scouting, strict organizational culture, and a well-managed team. The same can be said for Bronx politics and real estate developers who built apartment houses along newly built subway lines, helping to bolster and increase the Bronx's population. These new Bronxites were comprised of mostly European immigrants who abandoned crowded areas of Manhattan to move to the newly constructed Bronx neighborhoods. The Democratic Party nurtured these new immigrants and made them a very influential voting block that forced many high-profile candidates to visit and woo Bronx votes. The work of Democratic boss Edward Flynn is credited with heavily influencing Franklin Delano Roosevelt's decision to run for president and implement numerous federal projects in the Depression-era Bronx.

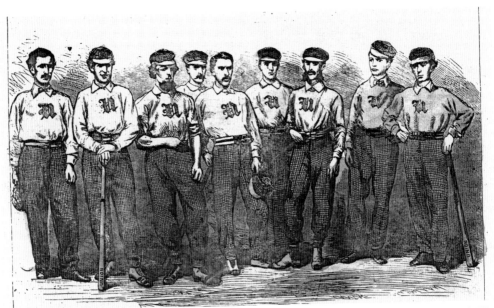

The Union Baseball Club of Morrisania (Bronx) was representative of the post–Civil War baseball boom. Local clubs helped spread the popularity of the game with New York serving as the baseball capital of the world. The Unions had a very successful team in 1867, winning a championship and eventually sending two players to the Cincinnati Reds, the National League's first professional club. (Courtesy of the Bronx County Historical Society.)

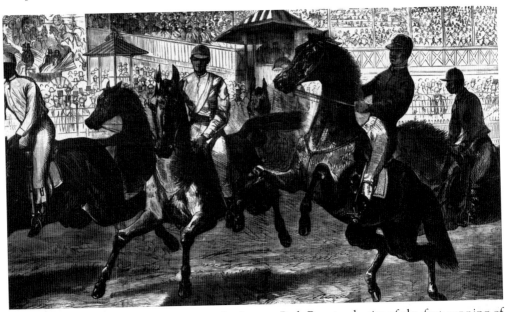

This watercolor shows jockeys racing at the Jerome Park Racetrack, site of the first running of the Belmont Stakes. Built in 1867, Jerome Park ushered in an era of post–Civil War gaming that would attract crowds by the thousands to sporting events in the Bronx. (Courtesy of the Bronx County Historical Society.)

THE EARLY DAYS

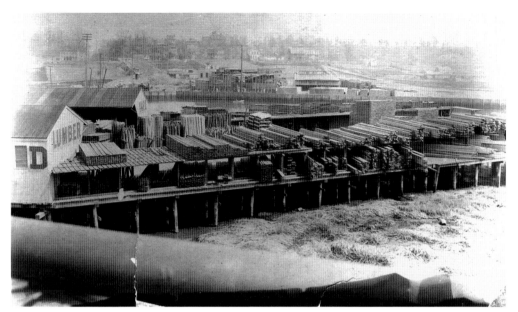

In the late 19th and early 20th centuries, waterfront lumberyards and coal yards were common sights as New York businesses thrived. This lumberyard stood at the southern end of the stadium site, erected over the recently filled-in Cromwell's Creek. This yard would be demolished when the stadium site was developed. (Courtesy of the Bronx County Historical Society.)

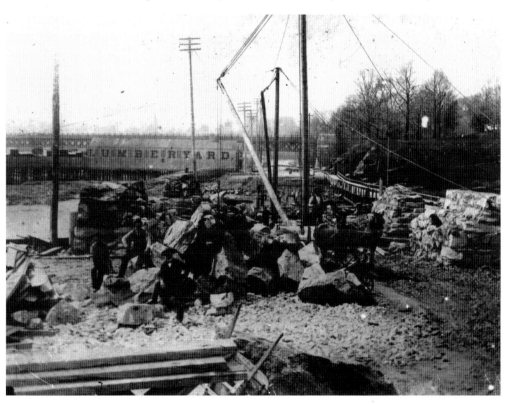

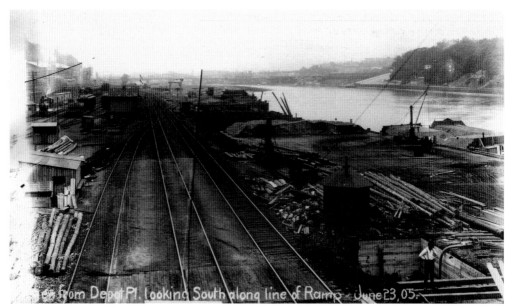

This waterfront image shows the early-20th-century industrial Bronx, roughly a half mile north of Yankee Stadium. To the right is the Manhattan shoreline, and in the distance is the steel frame of the Macombs Dam Bridge. A half century later, this site would become part of the Major Deegan Expressway, one of the highways that fans use to drive to the stadium. (Courtesy of the Bronx County Historical Society.)

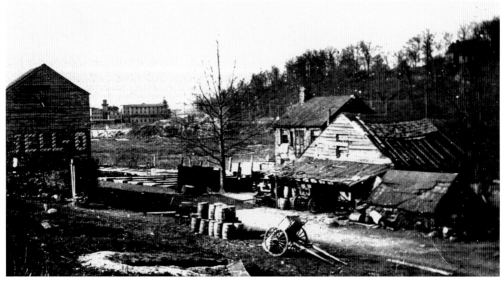

Prior to redevelopment, the neighborhoods around Yankee Stadium looked much like this image: a few farm buildings, swampy terrain, and difficult and sometimes treacherous roads. In this early-20th-century photograph, one can see the current stadium site in the distance, past the cluster of trees to the left of the Cromwell farm. (Courtesy of the Bronx County Historical Society.)

Harlem River Water Front Below Madison Ave. Bridge

At the dawn of the 20th century, the Bronx was economically growing and would be the beneficiary of New York City's northward urban expansion. Yankees owners Jacob Ruppert and Tillinghast L'Hommedieu "Cap" Huston understood this and capitalized on their investment. (Courtesy of the Bronx County Historical Society.)

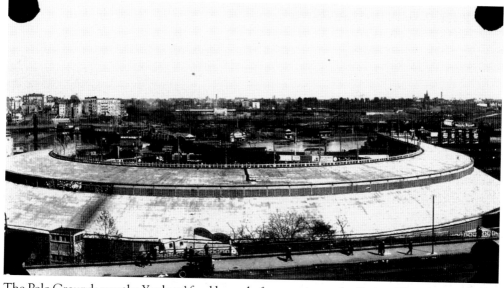

The Polo Grounds was the Yankees' final home before moving to the Bronx. This, the fourth ball field called the Polo Grounds, attracted fans to north Manhattan to see the very successful New York Giants baseball team. Until 1923 (when Yankee Stadium opened), the Giants were 10-time pennant winners and 3-time world champions. They dominated their rival tenant Yankees, beating them in the 1921 and 1922 World Series before evicting them and sending them across the river. In the distance, one can see the Interborough Rapid Transit (IRT) elevated train and the area that would become Yankee Stadium. (Courtesy of the Bronx County Historical Society.)

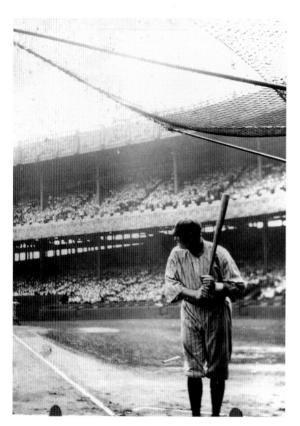

The Yankees' 1919 acquisition of George Herman "Babe" Ruth was a turning point in Yankees and baseball history. Ruth would change the previously hapless organization into a contender overnight and was a perfect match with the 1920s roaring New York personality. In his first season, his on-field talent shined as he led the team with a .376 batting average and 54 home runs, helping to create a winning culture that would dramatically change the organization's fortunes. (Courtesy of the Bronx County Historical Society.)

This March 18, 1918, photograph shows the most famous intersection in professional sports: 161st Street and River Avenue. Macombs Dam Bridge and Macombs Dam Park occupy both sides of the street, with the trolley car tracks and cobblestoned 161st Street rolling through the valley toward the Highbridge neighborhood. (Courtesy of the Bronx County Historical Society.)

The Yankees' Bronx move was facilitated by easy access to the new stadium site via the Macombs Dam Bridge. It was also a convenient way for fans to travel to both the Polo Grounds and Yankee Stadium, which were separated by a 20-minute walk. (Courtesy of the Bronx County Historical Society.)

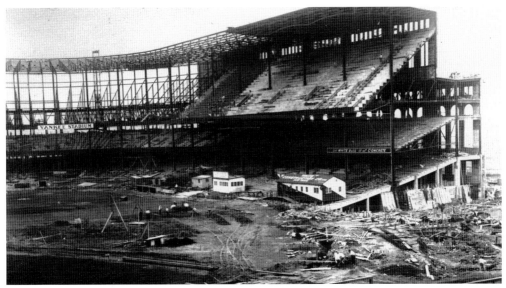

Following yet another successful Yankees season, the New York Giants severed their business relationship with the Yankees and forced them from the Polo Grounds. Yankees ownership needed to move the team and after searching around numerous New York sites settled on the intersection of 161st Street and River Avenue. Construction began in May 1922. (Courtesy of the Bronx County Historical Society.)

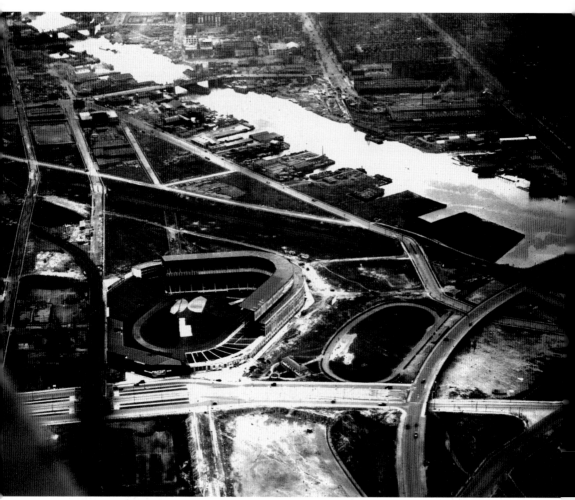

This aerial photograph shows an almost completed Yankee Stadium in April 1923. The stadium was quickly built in 284 days. It was the first three-tiered sports venue and would be the first ballpark to be called a stadium. From the start, ownership saw the stadium as much more than a ballpark; it was to be a multifaceted venue that would host different sporting events and produce year-round revenue. Visitors could reach the stadium by the subway IRT Lexington Avenue line (to the left of the stadium) or by car, utilizing the Macombs Dam Bridge (to the right). (Courtesy of the Bronx County Historical Society.)

THE EARLY DAYS

The opening day program features images of the two men most responsible for Yankee Stadium: owners Jacob Ruppert and Cap Huston. Ruppert, an Upper East Side beer magnate and U.S. congressman, eventually bought out Huston and ushered in unprecedented organizational success. Opening day was a grand celebration of a team on the rise. (Courtesy of the Bronx County Historical Society.)

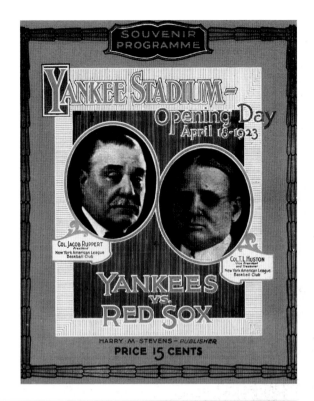

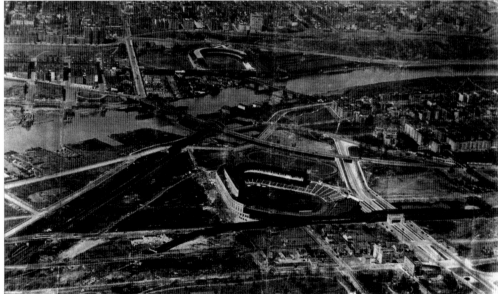

This overhead photograph shows the epicenter of professional baseball during the 1920s. Yankee Stadium opened on April 18, 1923, with the Yankees defeating the rival Boston Red Sox 4-1 on the strength of the stadium's first home run, appropriately hit by the great Babe Ruth. Later that year, the two teams would meet in their third straight World Series. (Courtesy of the Bronx County Historical Society.)

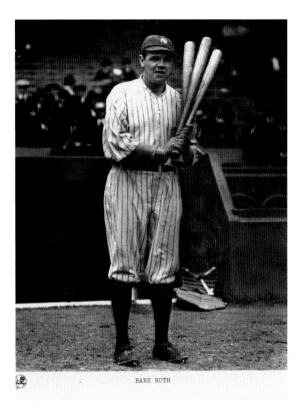

BABE RUTH

Babe Ruth was one of the most dominant baseball players of all time. After coming to the club following the 1919 season, Ruth led the team to seven pennants and its first four world championships. His on-field play and off-field persona made the Yankees extremely popular and gave them national exposure as a championship standard-bearer. This popularity enabled owners Jacob Ruppert and Cap Huston to build the most ambitious sports arena ever constructed, which is why it was nicknamed "the House That Ruth Built." (Courtesy of the Bronx County Historical Society.)

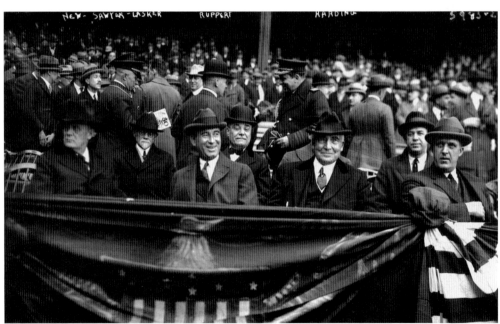

Opening day was an auspicious beginning to the big ballpark in the Bronx. Pres. Warren G. Harding was in attendance as John Philip Sousa's United States Marine Band played, and over 60,000 fans jammed into the stadium. (Courtesy of the Library of Congress.)

THE EARLY DAYS

Al Smith, New York's popular governor, was given the honor of throwing out the first pitch. (Courtesy of the Library of Congress.)

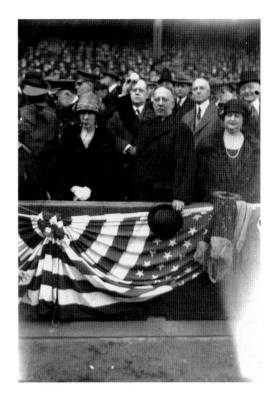

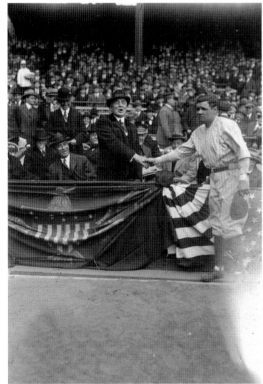

Babe Ruth greets President Harding before the game. (Courtesy of the Library of Congress.)

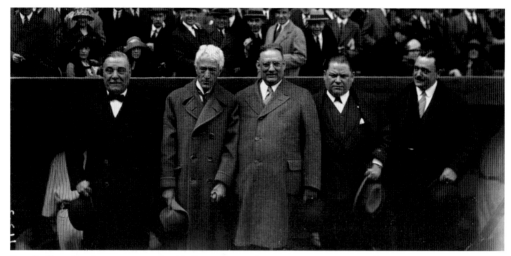

Baseball and politics mix as Jacob Ruppert and Cap Huston pose with Major League Baseball commissioner Kenesaw Mountain Landis (second from left) between them, Boston Red Sox owner Harry Frazee, and Bronx Democratic boss Edward Flynn. Flynn's influence as Bronx Democratic Party chair made the borough an important political stop for anyone running for major election and made him a powerful force in national politics. Yankee Stadium would be part of a downtown Bronx complex that included the Concourse Plaza Hotel and the Bronx County Courthouse building, both a few blocks east of Yankee Stadium. (Courtesy of the Library of Congress.)

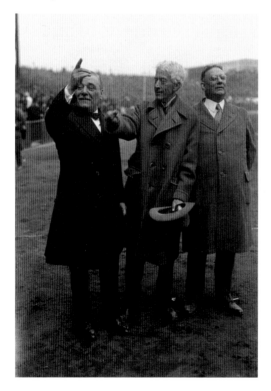

From left to right, Ruppert, Landis, and Huston stand on the warning track before the game. (Courtesy of the Library of Congress.)

The Bronx Nine, led by Babe Ruth, enter the playing field. (Courtesy of the Library of Congress.)

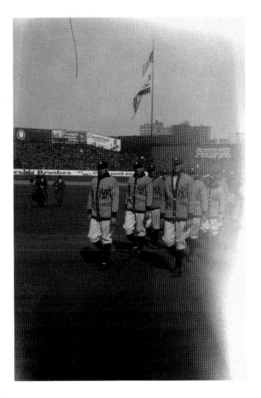

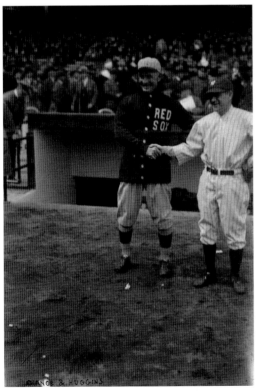

Red Sox manager Frank Chance and Yankees manager Miller Huggins shake hands before the game. (Courtesy of the Library of Congress.)

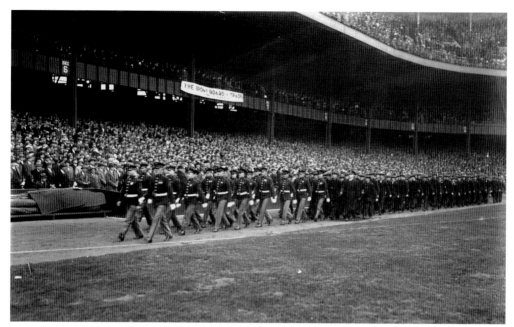

The Bronx Board of Trade, an important business and political organization, hangs its banner over the loge-level facade as the United States Marine Corps band walks up the first-base line. (Courtesy of the Library of Congress.)

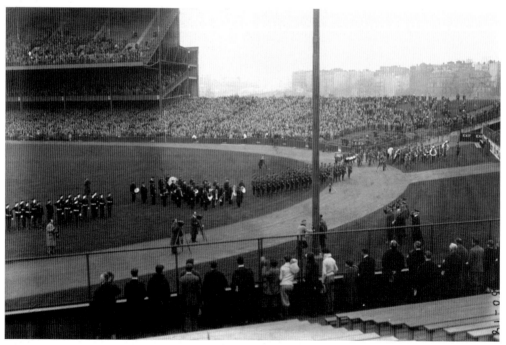

This is the 1923 bleacher view on the stadium's first opening day. Eventually the famous Yankee Stadium monuments would join the flagpole in center field. (Courtesy of the Library of Congress.)

THE EARLY DAYS

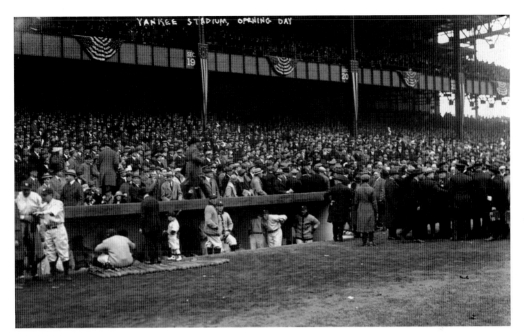

The Yankees prepare to take the field. (Courtesy of the Library of Congress.)

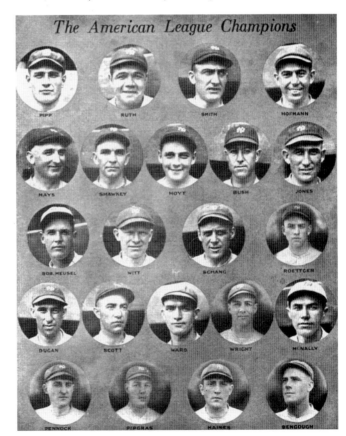

The 1923 Yankees were dominant in the regular season and defeated the New York Giants to capture their first World Series title. (Courtesy of the Bronx County Historical Society.)

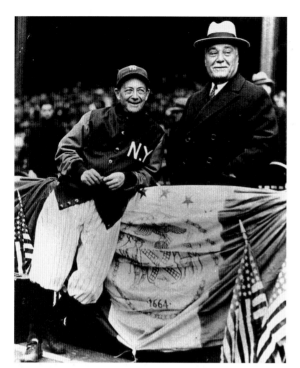

Miller Huggins, short in stature yet looming large as the team's first successful manager, and Jacob Ruppert, the wealthy and determined owner, formed a baseball relationship that suddenly ended with Huggins's death in 1929 after leading the team to six pennants and three world championships. In 1932, Huggins was the first organizational member to have a monument erected in center field. (Courtesy of the Bronx County Historical Society.)

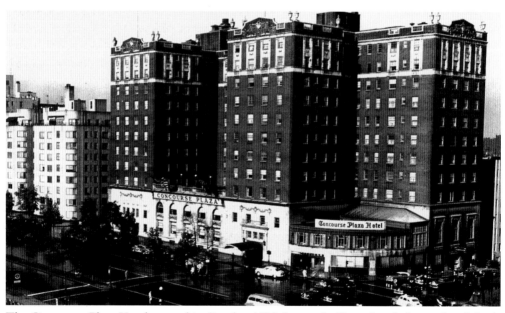

The Concourse Plaza Hotel opened in October 1923. It was the Bronx's only luxury hotel, built to accommodate the fans, visiting teams, and home players who would use Yankee Stadium, only a short walk down 161st Street. The Plaza was at the foot of the original Grand Concourse, which led visitors northward past grand art deco apartment houses to the southern end of Van Cortlandt Park. During the season, many Yankees players called the Plaza home, as it served as the borough's most prestigious gathering space. (Courtesy of the Bronx County Historical Society.)

THE EARLY DAYS

A Dynasty Is Born

The Yankees' Bronx move proved to be cathartic. While the team played in Manhattan from 1903 until 1922, it managed to win only two pennants, both coming after Babe Ruth's acquisition from the Boston Red Sox. The Yankees' first year in Yankee Stadium and the Bronx ended with the team's first World Series title at the expense of the hated New York Giants. The first World Series home run hit in the series (and in the stadium) was off the bat of a Giants player with only 60 career round-trippers: a soon-to-be-traded outfielder named Casey Stengel.

During the 1920s and 1930s, the Yankees became standard-bearers for baseball excellence, capturing 11 American League pennants and 8 World Series titles. Babe Ruth continued to capture fans' imaginations with his bombastic play on field and his huge personality, but the Yankees were steadied by cleanup hitter New York–born Lou Gehrig. Off the field, Yankees ownership continued to make smart personnel decisions, bringing in the right mix of talent that could maintain the team's winning ways while marketing the team to its tristate, upper-crust fan base that continued to fill the stands. Soon Yankee Stadium was *the* venue to hold large events, including Negro League games, championship boxing matches, college and professional football games, soccer matches, and other outdoor activities, competing with popular venues like the Polo Grounds in Manhattan and Brooklyn's Ebbets Field. As the Yankees continued to win and see their legend grow, the grand ballpark was quickly becoming an important component to its championship formula.

The Bronx grew around the stadium. The expansion of rapid transit northward facilitated new housing construction, and many immigrant families seized the opportunity to move their families out of Manhattan's crowded tenement districts and into the Bronx's new buildings. The Bronx featured a mixture of old law and new law tenement buildings and a large amount of luxurious art deco buildings along the Grand Concourse, around Yankee Stadium, and around its parkways and parks. Ethnic enclaves were created, with many eastern European Jews and Irish occupying neighborhoods surrounding Yankee Stadium, Italians creating their own "Little Italy" around the open-air market on Arthur Avenue, and African Americans living in Wakefield and soon moving into Mott Haven and Morrisania along with the growing numbers of Puerto Ricans. The Bronx was becoming an ethnically segregated melting pot; its population grew from 200,000 in 1900 to 1.5 million in 1950.

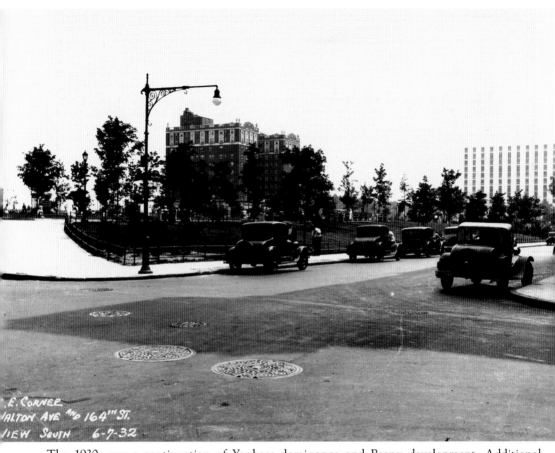

The 1930s saw a continuation of Yankees dominance and Bronx development. Additional seating was added to both the left field and right field grandstands, and the downtown Bronx continued to grow. In addition to the Concourse Plaza Hotel and Yankee Stadium, the iconic art deco Bronx County Courthouse (1934) was completed as a part of many Works Progress Administration (WPA) projects across the borough and city. (Courtesy of the Bronx County Historical Society.)

A DYNASTY IS BORN

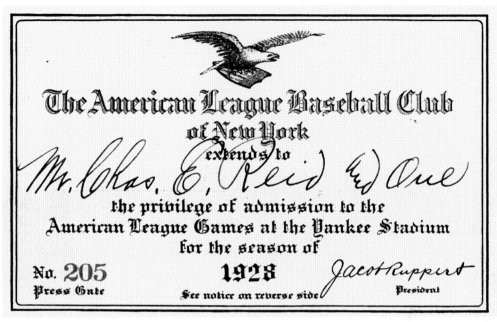

The American League Baseball Club
of New York
extends to

Mr. Chas. E. Reid & One

the privilege of admission to the
American League Games at the Yankee Stadium
for the season of

No. 205 1928 Jacob Ruppert
Press Gate See notice on reverse side President

Much to the delight of their season ticket holders, the Yankees captured yet another pennant and faced off against the Pittsburgh Pirates in the 1928 World Series. (Courtesy of the Bronx County Historical Society.)

NOTICE

THIS PASS IS A PERSONAL COURTESY AND IS NOT TRANSFERABLE. IF PRESENTED AT THE GATE BY ANY PERSON OTHER THAN THE ONE TO WHOM IT IS MADE OUT, IT WILL BE TAKEN UP AND CANCELLED.

NAME

ADDRESS 137th St. & 3rd Ave.

NOT VALID UNLESS SIGNED IN INK

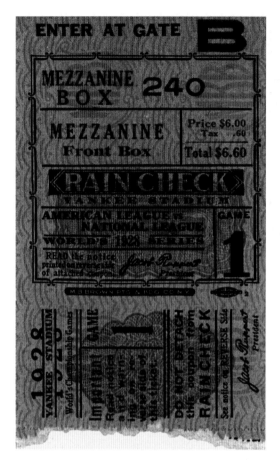

The year 1928 marked the Yankees' second straight World Series sweep over the St. Louis Cardinals. This second series win helped erase memories of the Cardinals' 1926 seven-game World Series victory over the Bombers. (Courtesy of the Bronx County Historical Society.)

WORLD SERIES TICKETS

Applications for tickets must be in writing accompanied by **certified check or money order.** Cash will not be accepted.

— PRICES —

Box Seats @ $6.60 for each ticket or $19.80 Per Set
Reserved Seats @ 5.50 " " " " $16.50 " "

Box and Reserved seats **sold only in sets of three** for the three games to be played at the Yankee Stadium.

25,000 **unreserved** Grand Stand tickets at $3.00 and 20,000 Bleacher tickets at $1.00 will be sold at the Stadium on day of game.

Address all applications to

The AMERICAN LEAGUE BASE BALL CLUB
OF NEW YORK
at 226 West 42nd St., New York City

The victorious Yankees hosted over 60,000 fans at the stadium for each World Series game. In a short decade, winning had become a way of life for the franchise. (Courtesy of the Bronx County Historical Society.)

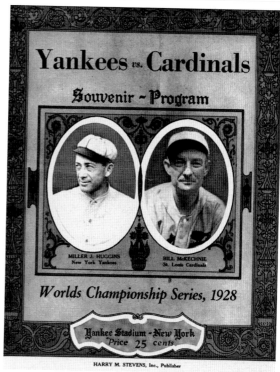

As Yankee Stadium became more and more popular, its image was used in a variety of ways, including as a proposed *King Kong* movie set and in numerous postcards and nostalgic keepsakes. (Courtesy of the Bronx County Historical Society.)

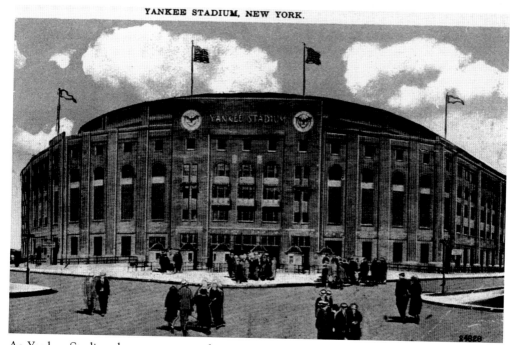

YANKEE STADIUM: 1923–2008

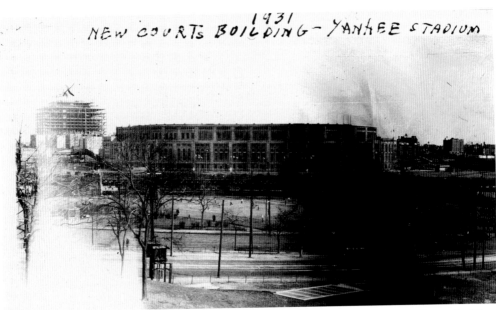

These two photographs show the construction of the new Bronx County Courthouse building on the Grand Concourse, above Yankee Stadium. The new county building opened in 1935, shifting the courts and governmental center of the borough to the 161st Street corridor. (Courtesy of the Bronx County Historical Society.)

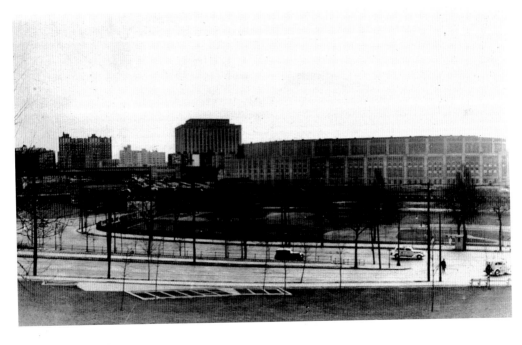

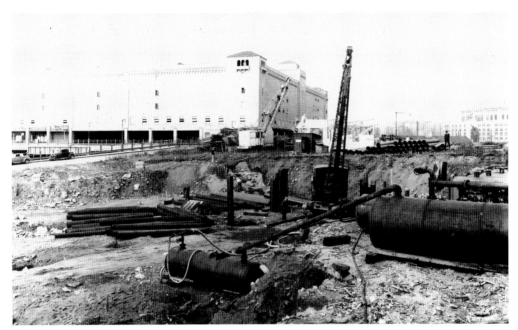

The Depression hit the Bronx as hard as any other borough, but Democratic boss Edward Flynn's political ties to Franklin Delano Roosevelt ensured federal public works projects that helped put many Bronxites back to work. Here one can see the building of the Bronx House of Detention during 1935. It was a structure that would stand until work began on the new Yankee Stadium redevelopment project in the early 21st century. (Courtesy of the Bronx County Historical Society.)

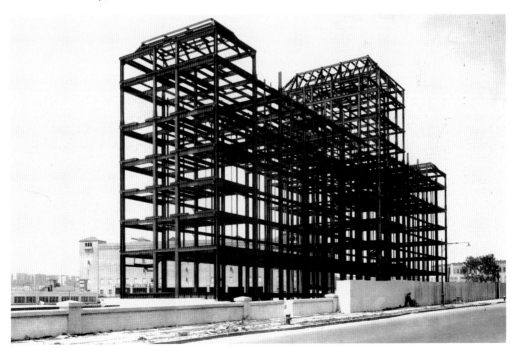

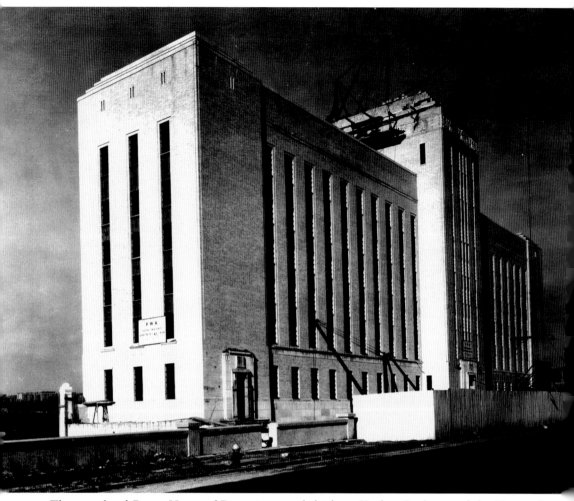

The completed Bronx House of Detention stands high, as Yankee Stadium and the Terminal Market complete the triangle of major south Bronx structures along the Harlem River. (Courtesy of the Bronx County Historical Society.)

A DYNASTY IS BORN

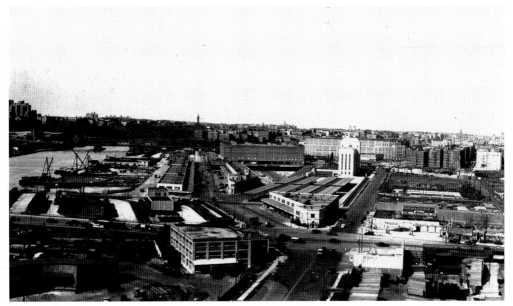

By the late 1930s, the Bronx was a much different place than it had been at the beginning of the 20th century. Yankee Stadium, the extension of rapid transit lines, and new housing being built across the borough signaled a dramatic change from backwater villages to a thriving borough of the great New York metropolis. (Courtesy of the Bronx County Historical Society.)

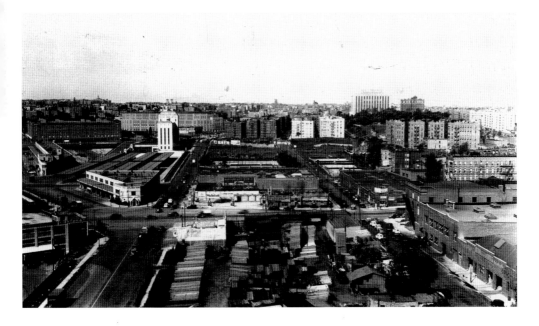

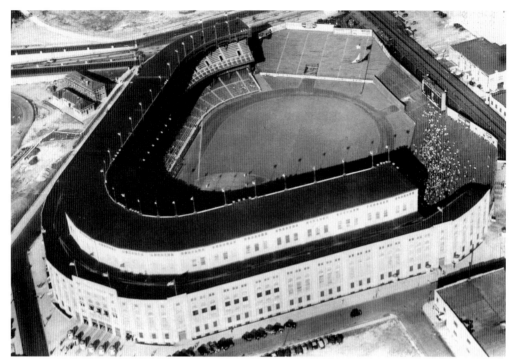

Jacob Ruppert's original plans called for a completely enclosed stadium. Due to financial concerns, this was not completed, but by the late 1930s, grandstand additions stretched the third tiers on both the third- and first-base lines to the bleachers. Also, spectators on the IRT subway platform could catch some of the action while waiting for their trains. (Courtesy of the Bronx County Historical Society.)

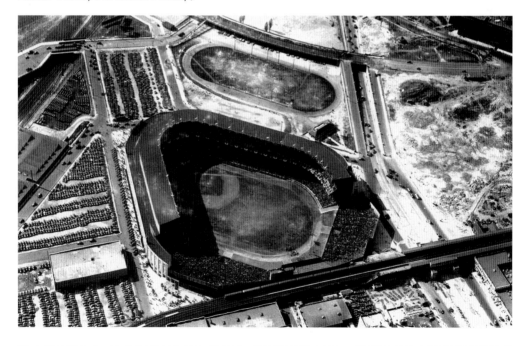

A DYNASTY IS BORN

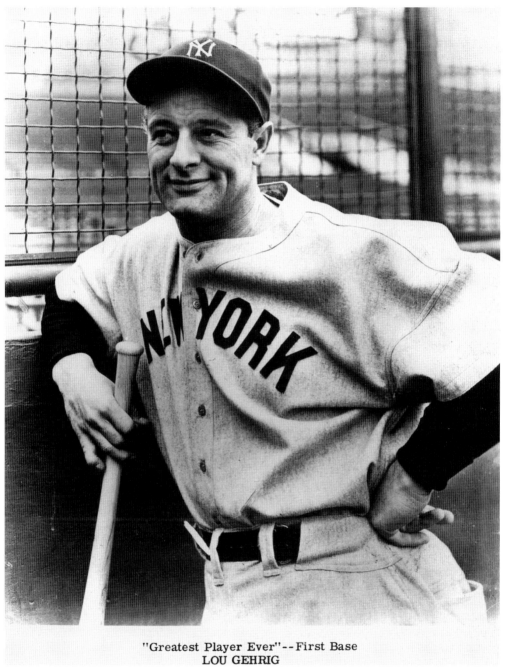

"Greatest Player Ever"--First Base
LOU GEHRIG

Lou Gehrig, "the Iron Horse," was a mainstay in the Yankees lineup from 1923 to 1939, where he batted an amazing .340, with 493 home runs and 1,995 RBIs. He holds the major-league record for grand slams (23), and his consecutive game streak of 2,130 stood until broken by Cal Ripken in 1996. His career and life were cut short by the disease that now bears his name, and appropriately his No. 4 was the first number retired in Yankee Stadium. (Courtesy of the Bronx County Historical Society.)

Yankees second baseman Tony Lazzeri was an important part of some of the greatest Yankees lineups from 1926 to 1937. Lazzeri was a power-hitting second baseman who hit in front of Lou Gehrig and Babe Ruth, stealing bases and scoring runs. He holds the American League record for most RBIs in a game (11) and was the first player to hit two grand slams in one game. (Courtesy of the Bronx County Historical Society.)

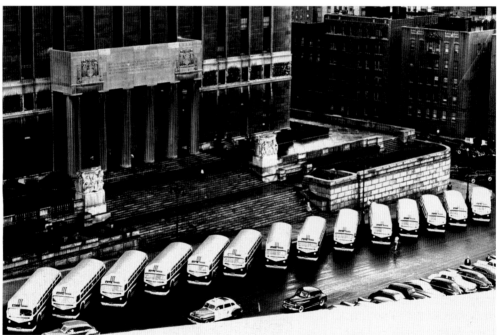

Buses line up in front of the new courthouse building waiting to go out on newly charted routes. Buses, trolleys, and subways were important means of bringing Bronxites to and from the stadium. (Courtesy of the Bronx County Historical Society.)

A DYNASTY IS BORN

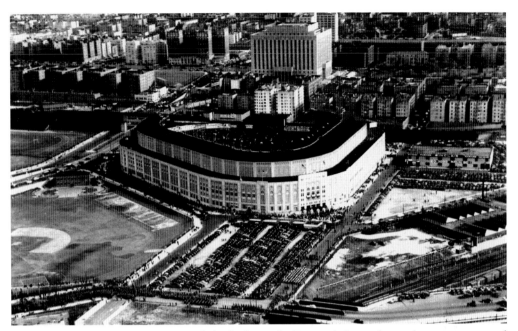

A packed Yankee Stadium now stands high above the Bronx skyline, playing host to year-round events. The popularity of the automobile began to attract fans from farther away. (Courtesy of the Bronx County Historical Society.)

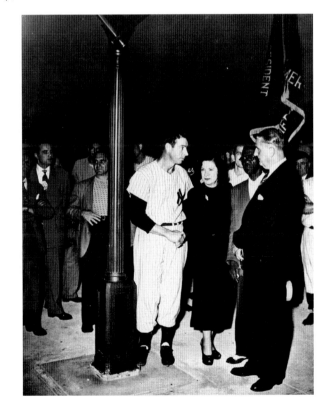

Joe DiMaggio, "the Yankee Clipper" and longtime center fielder, stands with Claire Ruth, Babe's wife, and Bronx borough president James Lyons at the dedication of Babe Ruth Plaza, located at the intersection of 161st Street and River Avenue. (Courtesy of the Bronx County Historical Society.)

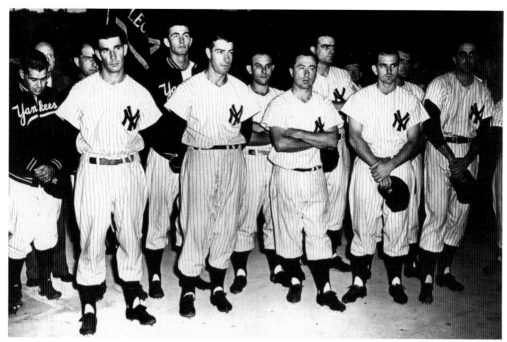

Joe DiMaggio and his teammates gather at the Babe Ruth Plaza dedication. DiMaggio carried the Yankees tradition from Babe Ruth, becoming an American icon and one of the greatest center fielders to ever play the game. (Courtesy of the Bronx County Historical Society.)

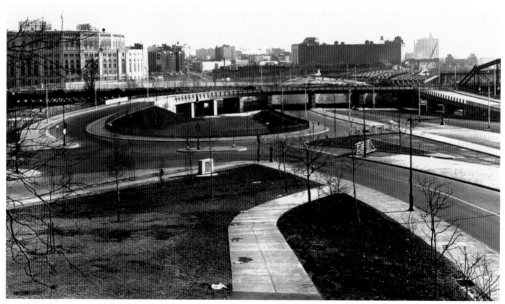

In the 1950s, the spread of highways and bridges connected New Yorkers in new and efficient ways. The opening of the Major Deegan Expressway (Interstate 87) provided quicker access to both Upstate New York and Long Island. This brought even more fans to the stadium by car. (Courtesy of the Bronx County Historical Society.)

A DYNASTY IS BORN

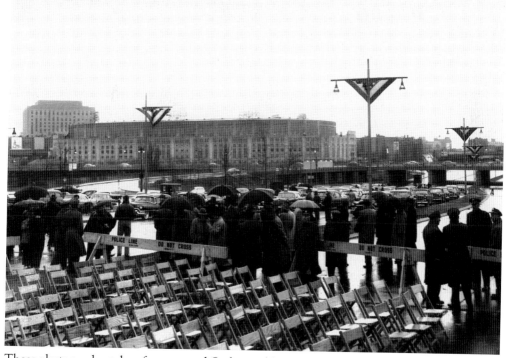

These photographs, taken from around Ogden and Jerome Avenues, show the new roadway and off-ramps that would soon be choked with traffic going around the stadium. (Courtesy of the Bronx County Historical Society.)

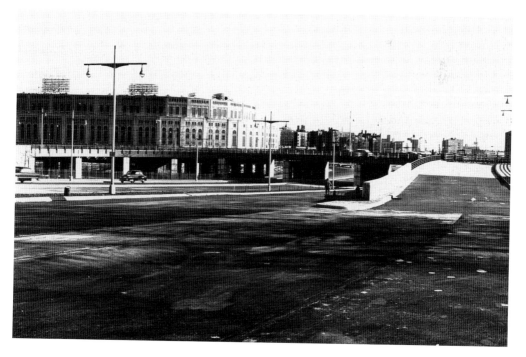

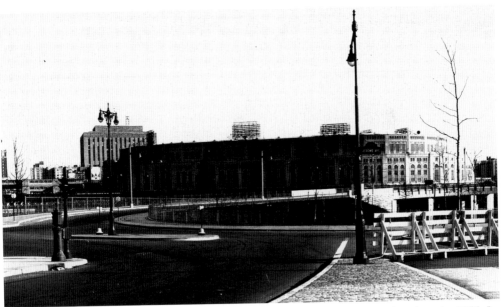

The Major Deegan Expressway was built in sections, starting in 1937 and ending in 1956. Its construction eased the heavy traffic on other congested Bronx roadways. It was one of many Robert Moses projects. (Courtesy of the Bronx County Historical Society.)

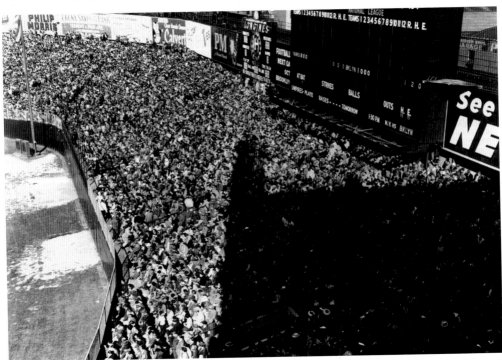

The well-dressed bleacher crowd watches the Yankees defeat the Brooklyn Dodgers in Game 1 of the 1947 World Series, behind solid pitching from winning hurler Spec Shea and closer Joe Page. (Courtesy of the Bronx County Historical Society.)

A DYNASTY IS BORN

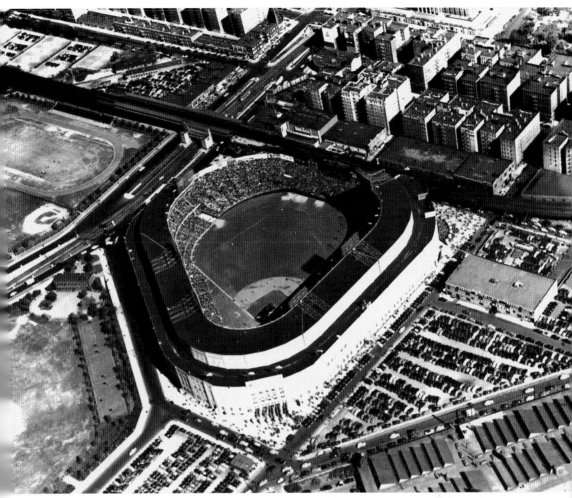

This is a bird's-eye view of a 10-3 Yankees victory over the rival Brooklyn Dodgers during the 1947 World Series. Clutch pitcher Allie "Superchief" Reynolds was the winner, as the Yankees would defeat the Dodgers in seven games for another World Series title. (Courtesy of the Bronx County Historical Society.)

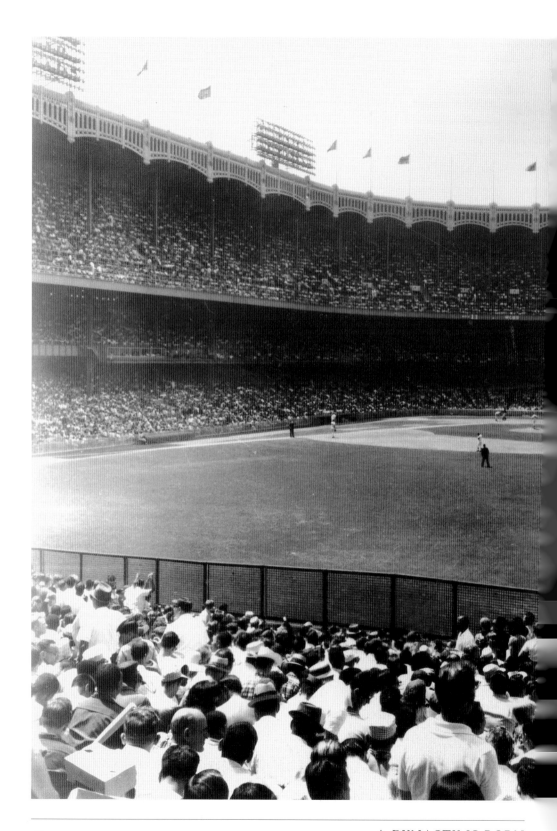

A DYNASTY IS BORN

A field-level view from the center field bleachers gave spectators an excellent perspective to argue balls and strikes and watch great outfielders like Joe DiMaggio and Mickey Mantle track down deep balls. (Courtesy of the Bronx County Historical Society.)

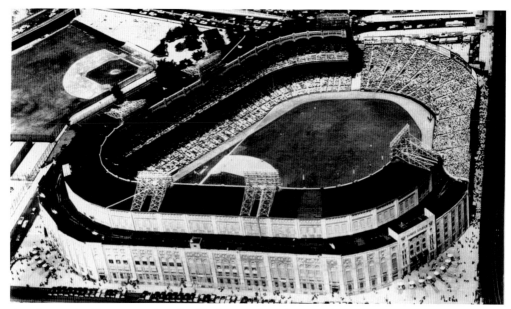

Another packed house watches the Yankees and Dodgers in the 1947 World Series. Notice the newly installed lights at the top of the stadium, at the time a little over a year old. Night baseball would gradually change the game, with eventual West Coast expansion that affected nationwide audiences. (Courtesy of the Bronx County Historical Society.)

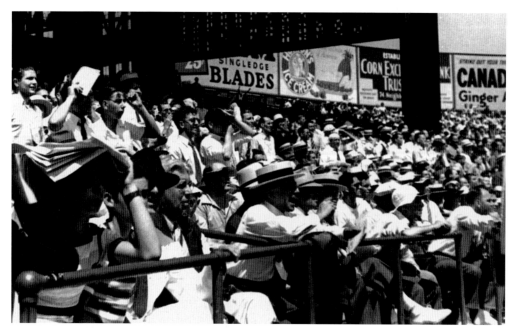

Yankee Stadium was the home of some of the game's most passionate and intelligent fans. As the rivalry between the Yankees, New York Giants, and Brooklyn Dodgers continued to heat up, baseball teams were closely identified with fans and the boroughs they represented. (Courtesy of Photofest.)

A DYNASTY IS BORN

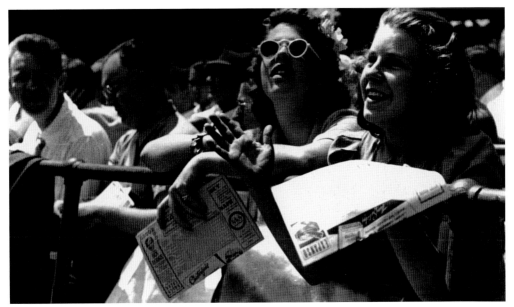

In addition to having great teams, New Yorkers also had icons that fans adored. In the 1950s, the question of who was the greatest center fielder revolved around a popular song about "Willie, Mickey, and the Duke." Willie Mays played for the Giants, Mickey Mantle played for the Yankees, and Duke Snider played for the Dodgers, and all of them led their teams to the World Series during the 1950s. (Courtesy of Photofest.)

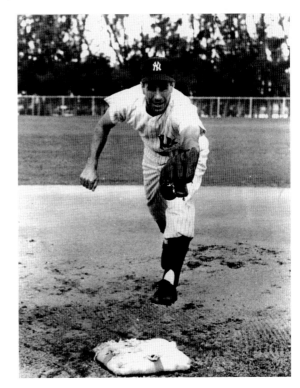

National Baseball Hall of Fame Brooklyn-born shortstop Phil Rizzuto played his entire career with the New York Yankees, contributing to seven World Series championship teams. He also became a well-known broadcaster for his "Holy Cow" exclamations and originality in the booth. (Courtesy of the Bronx County Historical Society.)

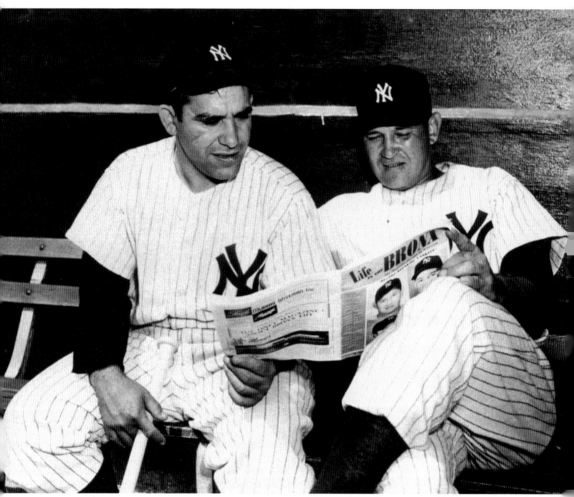

Yogi Berra, a 15-time all-star selection, 10-time World Series champion, and 3-time American League Most Valuable Player (MVP), sits next to Allie "Superchief" Reynolds, a stalwart of the Yankees' pitching staff that won six world championships between 1947 and 1954, while catching up on local Bronx news. (Courtesy of the Bronx County Historical Society.)

A DYNASTY IS BORN

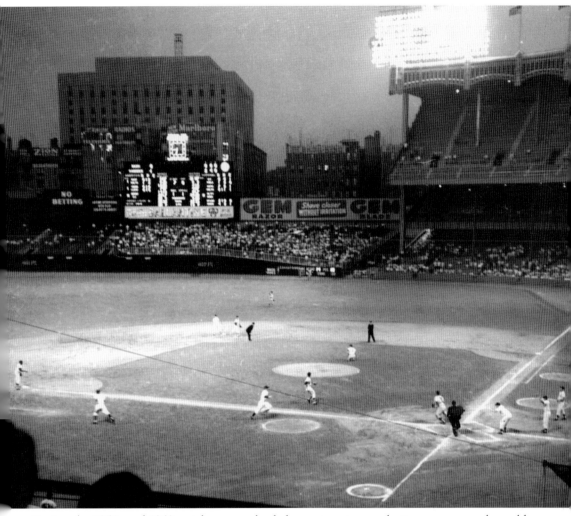

During the 1950s and 1960s, night games slowly began to gain popularity as more people could listen to the games on the radio or tune in on television. (Courtesy of Photofest.)

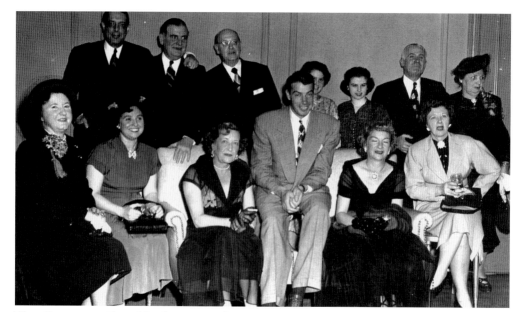

The Concourse Plaza Hotel was an elegant location to celebrate Yankees championships and served as an in-season home for many players who rented rooms. Here Joe DiMaggio (first row, third from the right) entertains guests at the hotel. (Courtesy of the Bronx County Historical Society.)

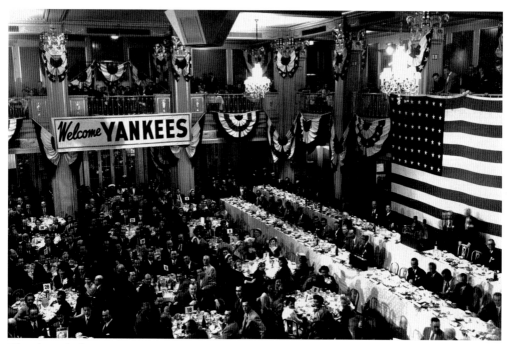

The Plaza's ballroom was the site of many weddings, meetings, proms, anniversaries, and birthday celebrations. Here another Yankees championship is celebrated. (Courtesy of the Bronx County Historical Society.)

A DYNASTY IS BORN

Players, like Yogi Berra (seated, third from the right), were frequently seen at the Plaza for postgame dinners and special appearances. (Courtesy of the Bronx County Historical Society.)

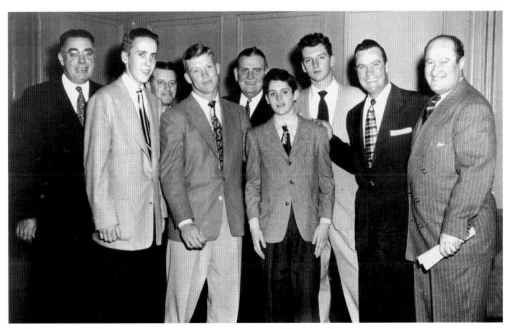

A youthful Mickey Mantle (front row, third from left) seems like only a face in the crowd, but his on-field play put him in rare company. Although Yankees fans were tough on "the Mick," he carried on the tradition of Joe DiMaggio as the next great Yankee player, occupying center field and hitting 536 home runs while being selected to 16 All-Star Games, winning seven World Series and three MVP awards, and hitting for the triple crown in 1956. (Courtesy of the Bronx County Historical Society.)

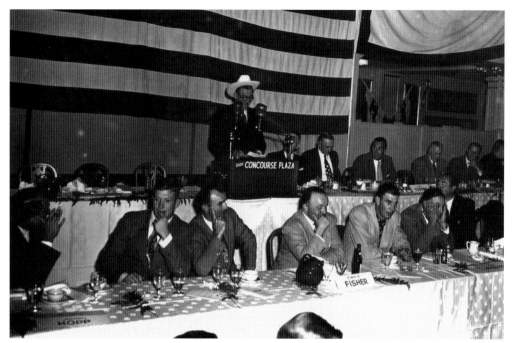

Borough Pres. James Lyons addresses the audience while Yankees players and organizational members sit in the front row of the dais. (Courtesy of the Bronx County Historical Society.)

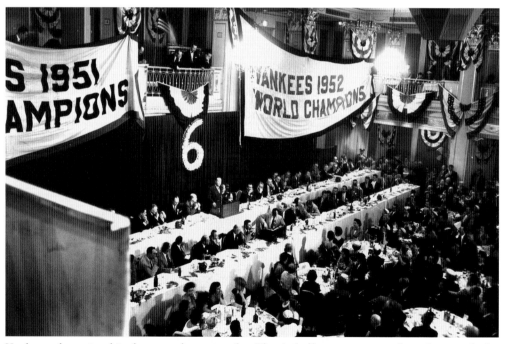

Yankees championship banners hang in the Plaza's ballroom, just as they decorated the stadium, as a not-so-subtle reminder of the Yankees' success. (Courtesy of the Bronx County Historical Society.)

A DYNASTY IS BORN

Edward "Whitey" Ford is known as one of the greatest Yankees pitchers of all time. The Queens-born lefty played from 1950 to 1967, capturing the 1961 Cy Young Award, winning six world championships, and being selected to eight All-Star Games. (Courtesy of the Bronx County Historical Society.)

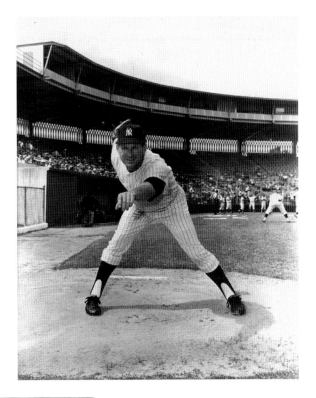

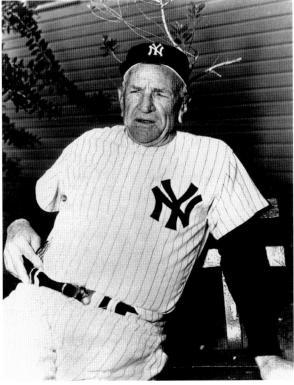

Casey Stengel was one of the most charismatic figures baseball has ever seen. His on-field success (seven World Series championships) was matched by his unorthodox managerial style, his interaction with the media, and his communication (called "Stengelese") that bucked many norms. He is one of few people associated with the Brooklyn Dodgers, New York Giants, New York Yankees, and New York Mets franchises. (Courtesy of the Bronx County Historical Society.)

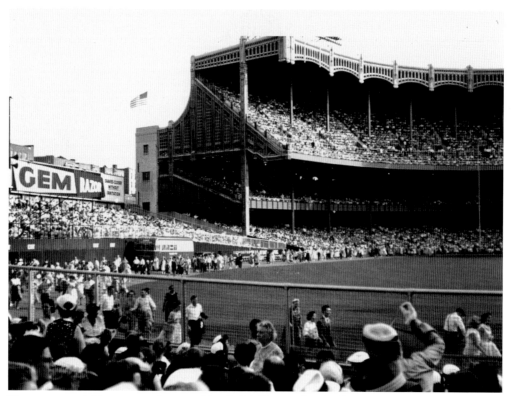

These are outfield pictures of an unidentified 1950s nonbaseball event at the stadium. Yankee Stadium was a popular venue for concerts, religious gatherings, and large outdoor performances. (Courtesy of the Bronx County Historical Society.)

A DYNASTY IS BORN

The Tradition Continues

By the 1960s, it was obvious the Yankees had a knack for recruiting and cultivating talent. Babe Ruth, the team's first star, gave way to Lou Gehrig, who gave way to Joe DiMaggio, who gave way to Mickey Mantle. Not only were these players great Yankees, they were American sports icons that baseball fans around the country idolized. With the expansion of television's popularity, Yankees players became household names as the team continued to capture titles. From 1923 to 1965, the team won 29 American League pennants and 20 World Series championships. During this period, the team never went more than four years without a championship, galvanizing the interlocking N and Y, pin-striped uniform, and grand ballpark as synonymous with champions and excellence in the greatest city in the world.

This was also a time that saw much change. For the better half of the 20th century, New York was home to the Manhattan Giants, the Brooklyn Dodgers, and the Bronx Yankees. During the 1940s and 1950s, the three teams were extremely competitive and frequently met one another in memorable, nerve-racking games that had the city's ears keenly listening to radio broadcasts. This was truly the golden age of New York baseball. This unfortunately ended in 1957 as both National League clubs were forced to move to California (the Giants to San Francisco and the Dodgers to Los Angeles) after they were both unable to persuade New York City, specifically master builder Robert Moses, to build them new stadiums. The Yankees were the only New York baseball team until 1962, when the New York Metropolitans (the Mets) were formed.

The Bronx was also changing. By the 1960s, white residents were moving to outer suburbs, and more southern blacks, black West Indians, and Puerto Ricans were replacing them. As demographics changed, the political scene also shifted. Under the old Irish bosses, the Bronx was a great beneficiary of governmental funds and was a can't-miss campaign stop for Democratic votes. As more Irish left, Italians and Jews soon grabbed political control while the growing minority groups also sought to exhibit influence. The result was diminished political capital, fractious, occasionally nasty ethnic politics, and dissenting voices. Like the aging Yankee Stadium, much of the housing stock in the neighborhoods south of Fordham Road were in desperate need of repairs, and upgrades yet were saddled by old rental laws that limited landlord profits by various rent controls.

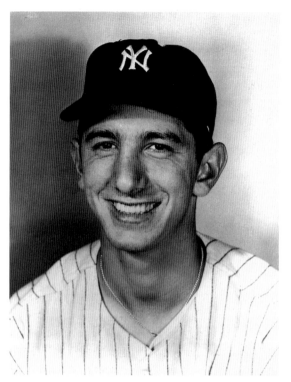

Alfred Manuel "Billy" Martin was known as a fiery, ultracompetitive player and manager. He was traded away from the Yankees during the 1957 season and would serve five tenuous, albeit successful, stints as Yankees manager. He was a fan favorite and a beloved player on four championship Yankees teams and one as a manager. (Courtesy of the Bronx County Historical Society.)

In 1955, Elston Howard became the first African American player in Yankees pinstripes. He played catcher, outfield, and first base; was selected for nine All-Star Games; won four world championships; and earned the 1963 American League MVP award. "Ellie" would later coach for the Yankees organization. (Courtesy of the Bronx County Historical Society.)

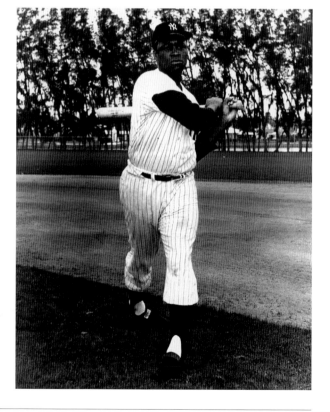

THE TRADITION CONTINUES

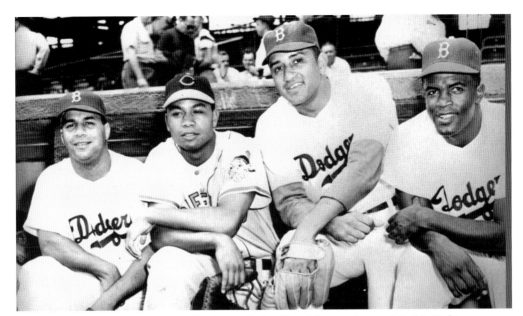

From left to right, Roy Campanella, Larry Doby, Don Newcombe, and Jackie Robinson were the first in a wave of black players that integrated baseball. All played in the Negro Leagues, as did many stars who did not make the major leagues. Yankee Stadium played host to numerous Negro League games and was once the home of the New York Black Yankees. (Courtesy of Anthony C. Greene.)

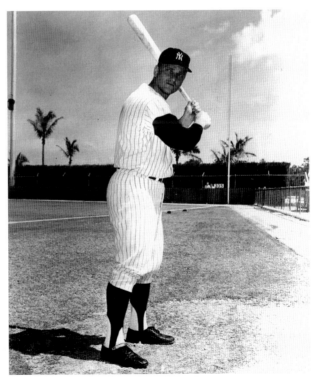

Roger Maris was the second player to hit 60 home runs in major-league history, eclipsing Babe Ruth's 61–home run mark during the storied 1961 season where he and teammate Mickey Mantle both chased history. Although Maris is given credit for his incredible accomplishment, he was maligned by the New York media and left the organization in 1966 amid much controversy. (Courtesy of the Bronx County Historical Society.)

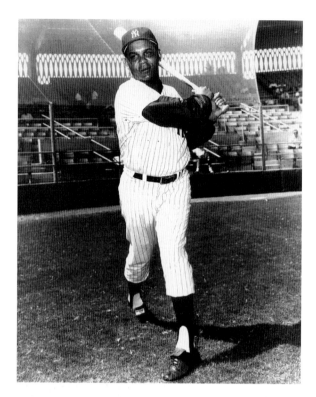

Panama-born Hector Lopez was an accomplished player as both an infielder and outfielder on five consecutive pennant teams and two World Series championship teams during the 1960s. He also was the first black manager in Triple A baseball. (Courtesy of the Bronx County Historical Society.)

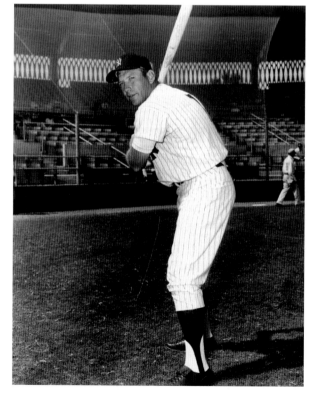

Mickey Mantle is one of the most beloved and revered Yankees of all time. Mantle took over center field from the great Joe DiMaggio and carried the Yankees' winning tradition to new heights. His astounding career numbers set records for switch-hitters and earned him first-ballot hall of fame honors. (Courtesy of the Bronx County Historical Society.)

THE TRADITION CONTINUES

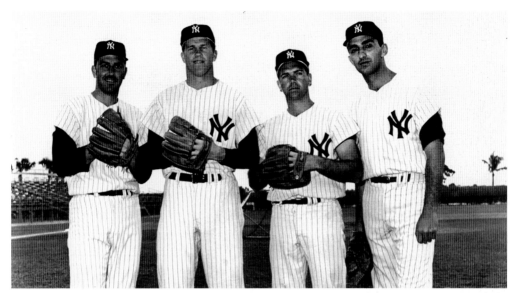

From left to right, Clete Boyer, Tony Kubek, Bobby Richardson, and Joe Pepitone round out the 1963 Yankees infield that captured the American League pennant yet fell short to the Dodgers in the World Series. (Courtesy of the Bronx County Historical Society.)

Joyce Kilmer Park, located adjacent to both the Concourse Plaza Hotel and Bronx County Courthouse, is a short walk from the stadium and frequently serves as a meeting point for those visiting the stadium. By the 1960s, the steps of the courthouse and the south end of Joyce Kilmer Park were convenient meeting places for both Yankees games and civic gatherings. (Courtesy of the Bronx County Historical Society.)

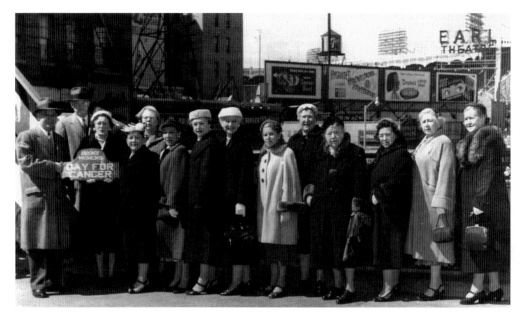

With Yankee Stadium as a backdrop, Bronx women pose to recognize a day of cancer awareness at the intersection of 161st Street and Walton Avenue. (Courtesy of the Bronx County Historical Society.)

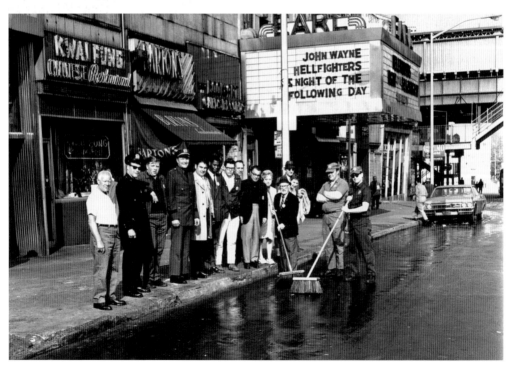

Fans, police officers, and department of sanitation crew members pose in front of the Earl Theatre, adjacent to the stadium, after a Yankees home game. (Courtesy of the Bronx County Historical Society.)

THE TRADITION CONTINUES

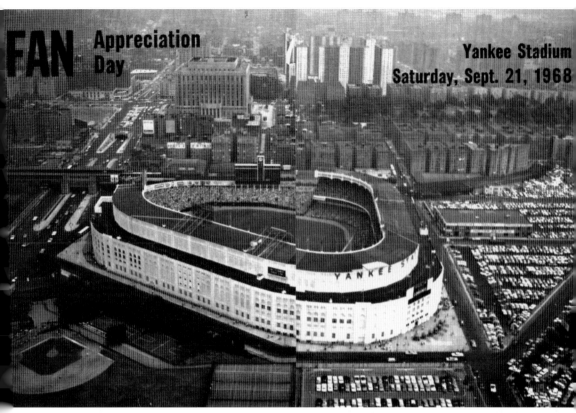

Fan appreciation day on September 21, 1968, was held toward the end of another subpar Yankee season. The year 1968 would be tumultuous on and off the diamond, as the Yankees finished 20 games behind the Detroit Tigers, with an 83-79 record. It would also be Mickey Mantle's final season in pinstripes. (Courtesy of the Bronx County Historical Society.)

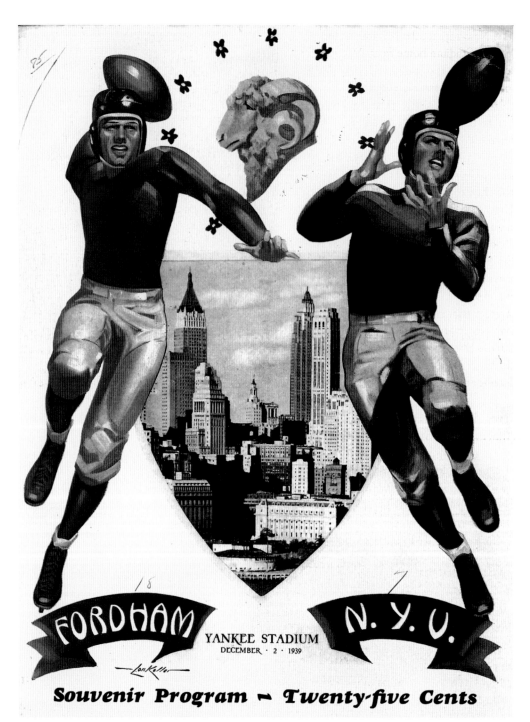

FORDHAM

N. Y. U.

YANKEE STADIUM
DECEMBER · 2 · 1939

Souvenir Program ~ Twenty-five Cents

Yankee Stadium played host to dozens of college football games, including great Army-Navy and historic Grambling University versus Southern University games. Here two Bronx schools went head to head, as Fordham University took on New York University in 1939 with the Rams winning 20-7. (Courtesy of the James J. Houlihan collection.)

The New York football Giants called Yankee Stadium home from 1956 to 1973. In that time, the team saw its popularity grow as it became more successful thanks to high-profile games and players. Led by coach Allie Sherman, the 1961 team finished 10-3-1 and captured first place in the Eastern Conference but lost to the Green Bay Packers 37-0 in the championship game. The storied Giants and Bears franchises clashed in numerous historic games. During the 1956 season, the team's first in Yankee Stadium, the Giants would capture a world championship, defeating the Bears 47-7, utilizing the same sneaker strategy that enabled the team to navigate icy field conditions in the famous Sneaker Bowl against the Bears decades earlier. (Courtesy of the James J. Houlihan collection.)

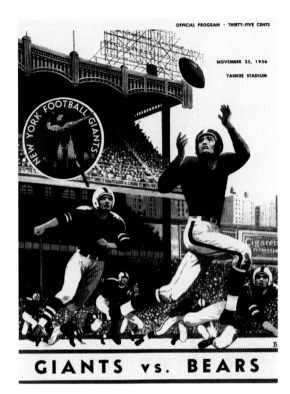

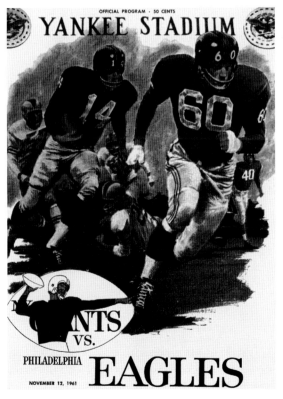

The Giants battled old rivals like the Philadelphia Eagles, carrying over old memories. (Courtesy of the James J. Houlihan collection.)

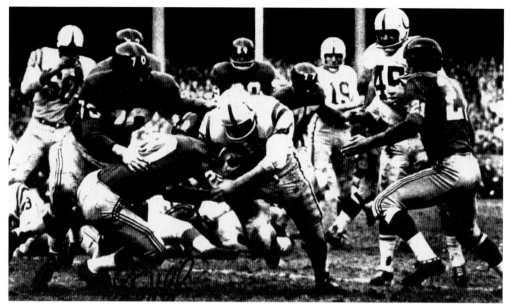

"The Greatest Game Ever" was played on December 28, 1958, between the Baltimore Colts and the Giants. Broadcast nationwide, this exciting game is credited with introducing the baseball-frenzied country to the drama and excitement of professional football. The Giants lost this championship game 23-17 after an overtime Alan Ameche touchdown plunge. (Courtesy of the James J. Houlihan collection.)

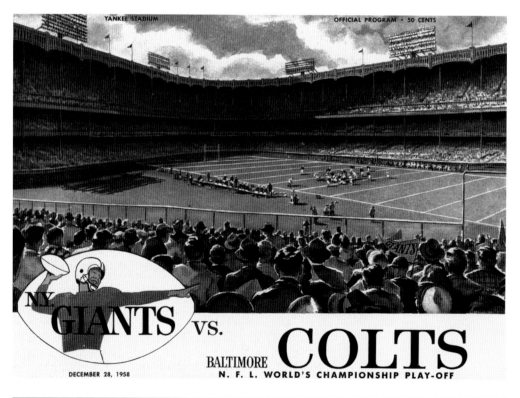

THE TRADITION CONTINUES

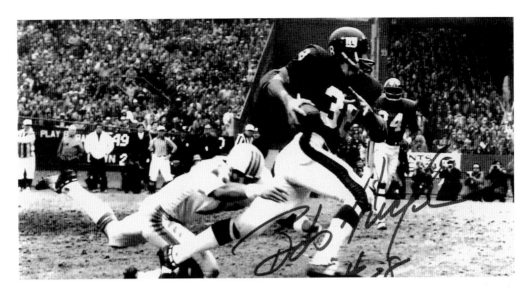

While in the Bronx, Giants icons like Y. A. Title, Fran Tarkenton, Sam Huff, Frank Gifford, and Roosevelt Grier led numerous Giants teams to successful seasons and gave Yankees fans a team to cheer for in the baseball off-season. (Courtesy of the James J. Houlihan collection.)

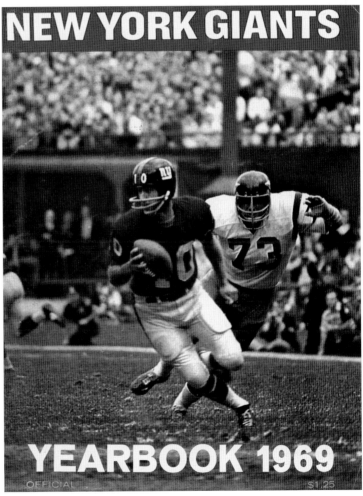

When Yankee Stadium closed its doors for a major reconstruction in 1973, the Giants left the Bronx and played two seasons at the Yale Bowl in New Haven, Connecticut, and one season at Shea Stadium in Queens before opening Giants Stadium in East Rutherford, New Jersey, in 1976. (Courtesy of the James J. Houlihan collection.)

In the late 19th and early 20th centuries, boxing was America's largest spectator sport. Here the Yankees' first owner, Frank Farrell, watches a boxing match at the Polo Grounds, New York's early premier outdoor arena. Yankee Stadium was built to compete with and ultimately unseat the Polo Grounds' reputation. (Courtesy of the Library of Congress.)

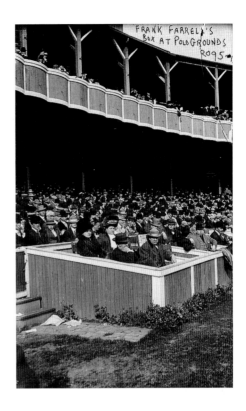

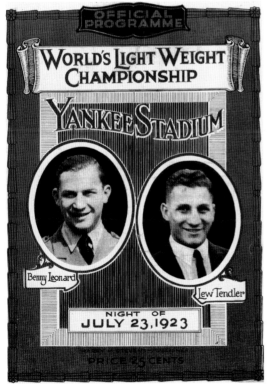

Yankee Stadium was the scene of 30 championship boxing matches and dozens of nonchampionship bouts throughout the years. The first championship bout paired lightweights Benny Leonard and Lew Tendler on July 23, 1923, in a riveting fight, with Leonard winning a 15-round decision. From there, Yankee Stadium would be one of the world's largest boxing venues. (Courtesy of the James J. Houlihan collection.)

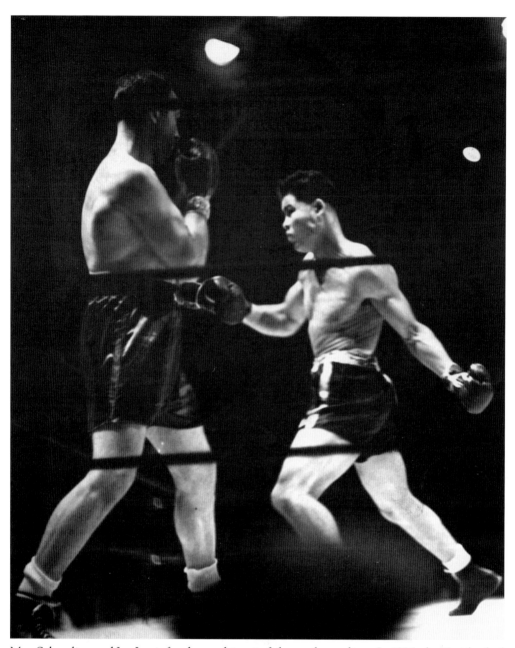

Max Schmeling and Joe Louis fought two historic fights at the stadium. In 1936, the Nazi-backed fighter handed "the Brown Bomber" his first loss in a 12th-round knockout. But two years later Louis avenged his loss by knocking Schmeling and the Nazi propaganda machine out in the first round. (Courtesy of the James J. Houlihan collection.)

THE TRADITION CONTINUES

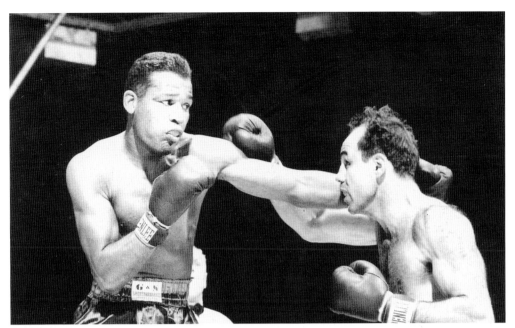

On August 24, 1949, "Sugar Ray" Robinson, arguably the greatest pound-for-pound fighter of all time, wowed the Yankee Stadium crowd by registering a seventh-round technical knockout of Steve Belloise. (Courtesy of the James J. Houlihan collection.)

In one of the best fights in one of boxing's all-time great rivalries, Robinson lost his middleweight championship belt to Carmen Basilio in a 15-round decision. (Courtesy of the James J. Houlihan collection.)

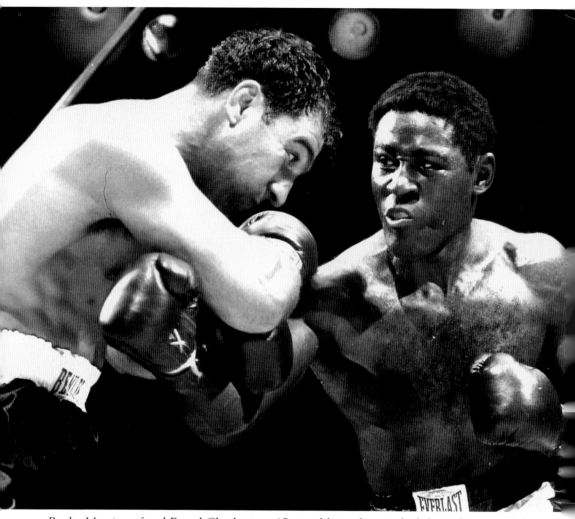

Rocky Marciano faced Ezzard Charles in a 15-round bout that marked the only time a fighter stood in with "the Brockton Blockbuster" for the full 15 rounds. Marciano won a decision and the subsequent rematch. (Courtesy of the James J. Houlihan collection.)

THE TRADITION CONTINUES

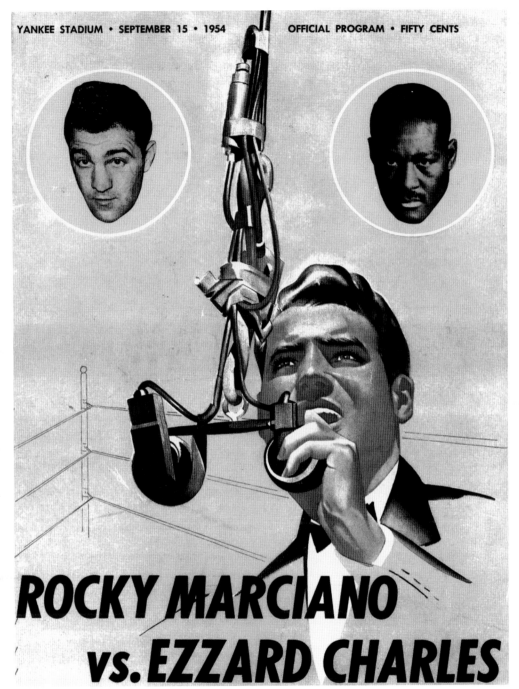

ROCKY MARCIANO
vs. EZZARD CHARLES

Bronx fight fans were treated to Marciano matches on numerous occasions. Marciano is one of boxing's all-time greats and has the distinction of retiring as the only undefeated heavyweight champion. (Courtesy of the James J. Houlihan collection.)

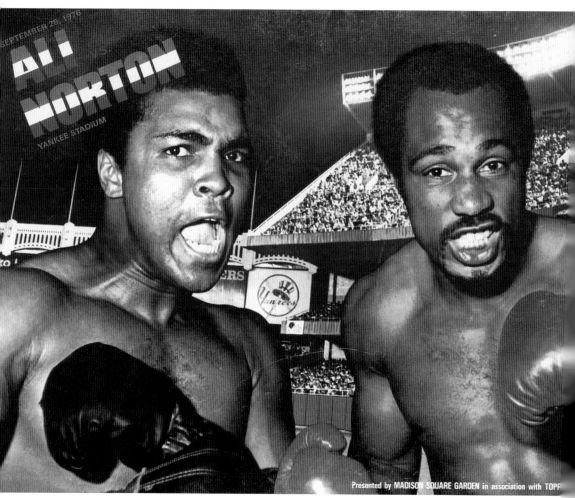

Muhammad Ali, "the Greatest of All Time," fought the hard-nosed Ken Norton on September 26, 1976, in the newly renovated Yankee Stadium. Ali won a close 15-round decision, completing this great boxing trilogy by Ali winning two close fights and losing one to Norton. (Courtesy of the James J. Houlihan collection.)

THE TRADITION CONTINUES

Following the 1973 season, the Yankees organization convinced the city to pay for a complete renovation and reconstruction of the old Yankee Stadium and the surrounding area. This cost New York City taxpayers well over $150 million. (Courtesy of the Bronx County Historical Society.)

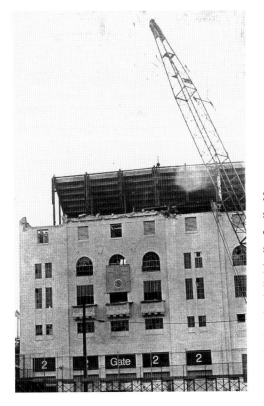

Stadium changes included opening the stadium's roof, removing the old frieze that once crowned the ballpark, building additional seating in the upper deck, removing the old pillars that once supported the upper decks and obstructed seats, removing the center field bleacher seats, installing a video instant replay board, and adding parking spaces, yet little money was spent on improving the crumbling neighborhoods around the multimillion-dollar facility. (Courtesy of the Bronx County Historical Society.)

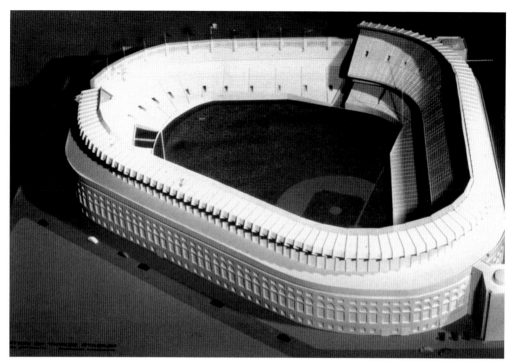

This model shows a scaled view of the newly renovated stadium. (Courtesy of the Bronx County Historical Society.)

New improvements included better access ramps from parking areas and surrounding street lots. (Courtesy of the Bronx County Historical Society.)

This picture shows new sections of the renovated stadium and the famous Louisville Slugger bat (an exhaust pipe) to the right that served as an important landmark for those meeting at the stadium. (Courtesy of the Bronx County Historical Society.)

New escalators and external escalator shafts made level-to-level movement much easier than the old ramps. (Courtesy of the Bronx County Historical Society.)

The gates were widened and expanded for easier and quicker entrance into the stadium's main level. (Courtesy of the Bronx County Historical Society.)

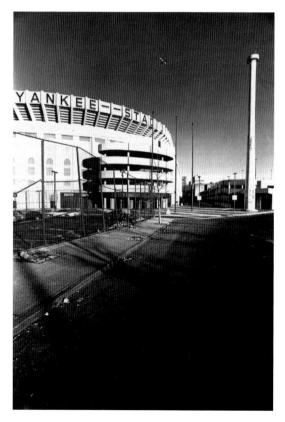

Additional parking garages and parking lots were added to accommodate fans who did not feel safe taking public transportation. Also, the player's lot was moved next the stadium on Ruppert Place (to the left). (Courtesy of the Bronx County Historical Society.)

THE TRADITION CONTINUES

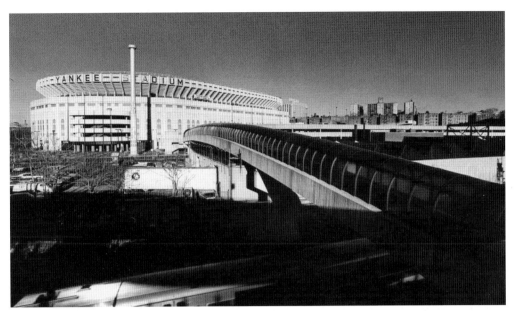

Amid much local devastation, the newly renovated stadium was a shiny building amid a smoldering south Bronx landscape. Later critics would argue that too much public money was spent on the ballpark and not enough on the surrounding neighborhoods. (Courtesy of the Bronx County Historical Society.)

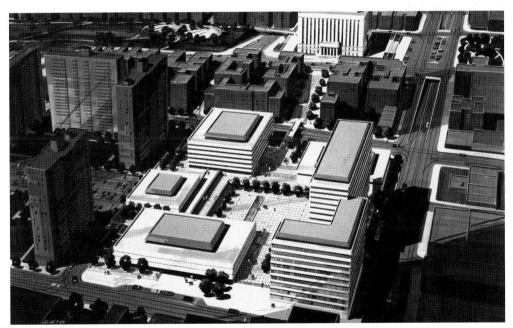

According to plans, the newly renovated stadium was part of a larger redevelopment project that was to include upgrades to the Bronx County Courthouse and the construction of new court buildings east on 161st Street. By the 1990s, much of this work had been accomplished. (Courtesy of the Bronx County Historical Society.)

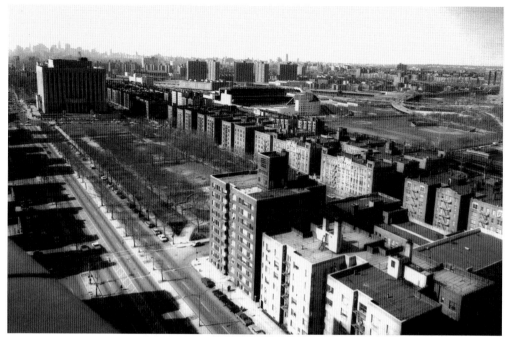

This overhead view shows the pre-redevelopment corridor in 1973. (Courtesy of the Bronx County Historical Society.)

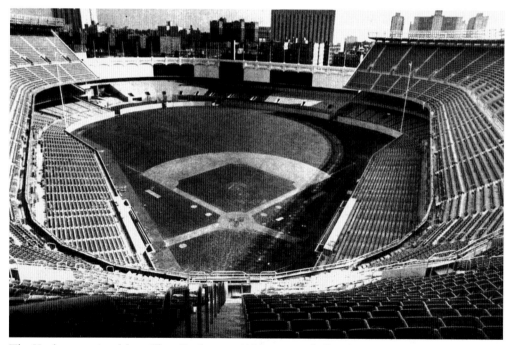

The Yankees returned from Shea Stadium in 1976 to a new ballpark. Changes to the dimensions, structure, and playing surface were so dramatic that players considered it a totally different stadium. (Courtesy of the Bronx County Historical Society.)

THE TRADITION CONTINUES

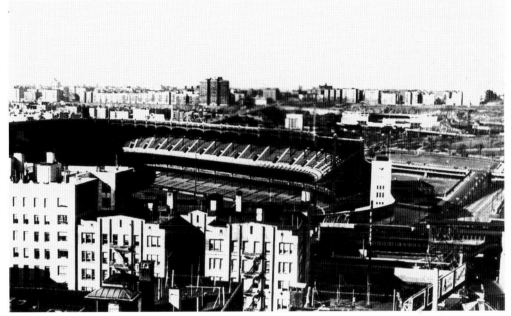

This is a 1973 photograph taken from Franz Siegel Park showing the pre-renovated stadium. (Courtesy of the Bronx County Historical Society.)

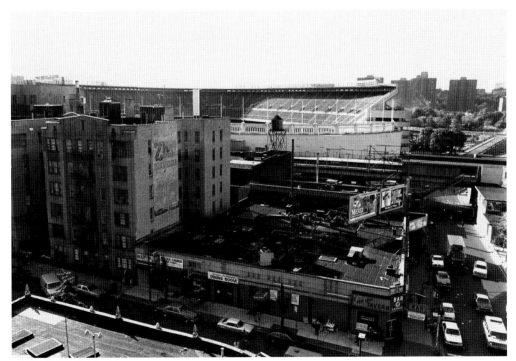

This 1976 photograph taken from the Bronx County Courthouse shows the significant changes to the stadium. (Courtesy of the Bronx County Historical Society.)

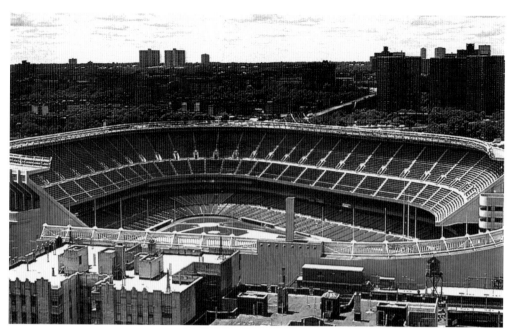

This 1976 skyline photograph captures the newly opened roof, mercury vapor lights, center field sound system, and IRT Lexington Avenue platform. One of the significant changes to the building was a closing off of the subway platform field view. (Courtesy of the Bronx County Historical Society.)

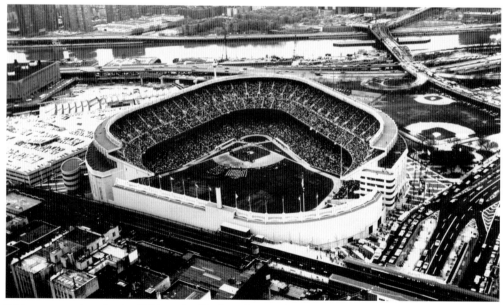

This was opening day in 1976 as the Yankees began their first season in the new "House That Ruth Built." The year 1976 would prove to be a magical season as the Yankees would win the American League pennant thanks to a dramatic Chris Chambliss home run against the Kansas City Royals. (Courtesy of the Bronx County Historical Society.)

THE PIN-STRIPED LEGACY

The 1980s and early 1990s were tough on the Yankees. Owner George M. Steinbrenner's antics wore thin and after the team lost to the Dodgers in the 1981 World Series were largely unsuccessful. It would be 15 years until the team would capture another pennant and world title.

During this time, the Yankees were able to spend and attract talent but seriously lacked the pitching and effective management to get back to the World Series. This all changed with the hiring of Joe Torre as manager following the team's return to the play-offs in 1995 under manager Buck Showalter.

Torre was yet another unlikely manager who was extremely successful in the pressure-packed Yankees culture. He made the team a perennial contender again, capturing six American League pennants and four world championships. Torre's calm demeanor was the perfect balance to Steinbrenner's very public persona and wallet. General manager Brian Cashman inherited Bob Watson's 1996 team and was able to continue the winning tradition, putting together highly successful teams in a new era of huge salaries and free agency.

As the Yankees rose during the 1990s, the Bronx also underwent a renaissance. Burned-out, abandoned buildings, once the homes of drug addicts and dealers, were slowly demolished and replaced with new housing. Much of this was due to Bronx-born Mayor Ed Koch's administration and the vigor of Borough Pres. Fernando Ferrer, but local community organizations and residents who did not leave were also instrumental in rebuilding many of the south Bronx neighborhoods. By the late 1990s, the Fort Apache Bronx was effectively erased from the landscape, creating new neighborhoods that would be unrecognizable to 1970s and 1980s visitors. It stands as one of the greatest stories of steadfastness, determination, and dedication in a borough built on hard work.

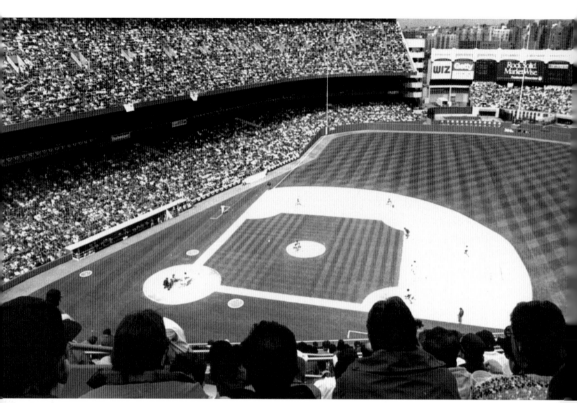

This photograph was taken from the first-base line, loge level, looking down on the action. The newly renovated stadium was extremely fan friendly, featuring vastly improved sight lines and additional upper-deck seating. (Courtesy of the Bronx County Historical Society.)

THE PIN-STRIPED LEGACY

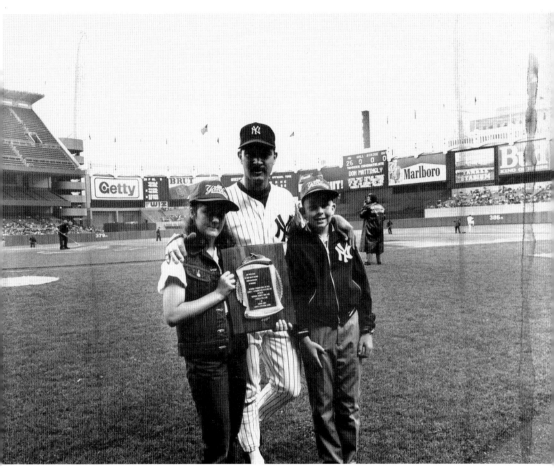

Don Mattingly was a fan favorite and among the best all-around players in the 1980s and 1990s. Although injuries shortened his career, he was able to capture one American League MVP award and remains a fan favorite. He later served as hitting coach under manager Joe Torre. (Courtesy of the Bronx County Historical Society.)

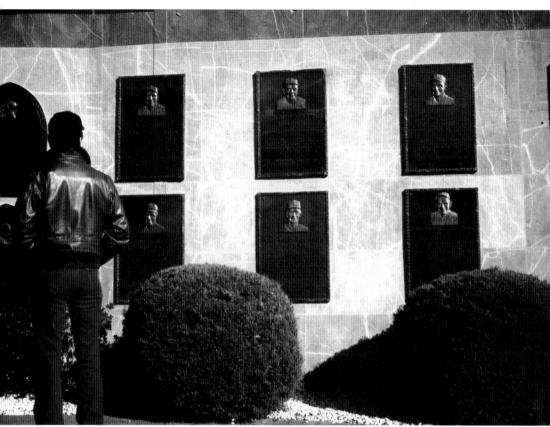

Monument Park is one of the most hallowed places in all of professional sports. It was built in left-center field after the outfield walls were shortened. It featured the retired player numbers, six monuments, and plaques to players and events that took place in Yankee Stadium. (Courtesy of Margaret Beirne.)

THE PIN-STRIPED LEGACY

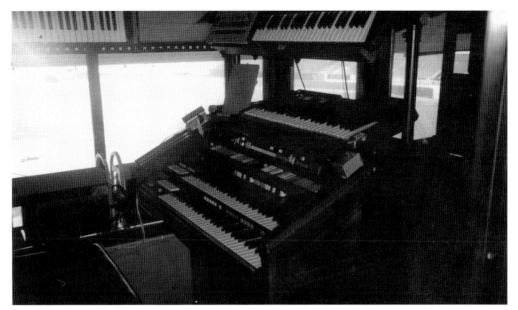

The famous Hammond organ in the press box entertained fans for decades with live music during games. Longtime organist Eddie Layton was a stadium mainstay until his retirement. (Courtesy of Margaret Beirne.)

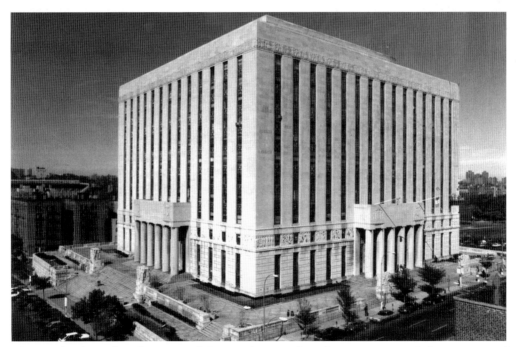

The newly cleaned and renovated Bronx County Courthouse was unveiled as a part of improvements along the 161st Street corridor. These improvements were part of a larger plan to revitalize and improve devastated areas of the borough. (Courtesy of the Bronx County Historical Society.)

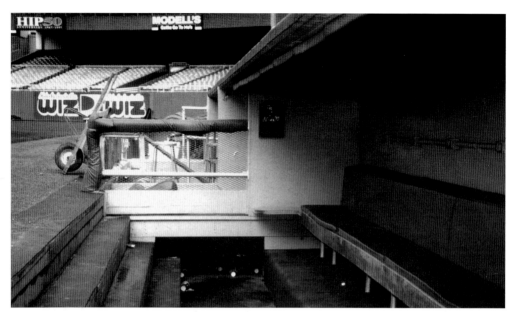

The Yankee dugout, on the first-base line since 1947, is where Yankees managers and players watched some of the greatest moments in organization history. Arguably the best vantage point to watch the game from, the dugout featured a plaque on the wall to longtime equipment manager Pete Sheehey, air-conditioning, and heat ducts. (Courtesy of Margaret Beirne.)

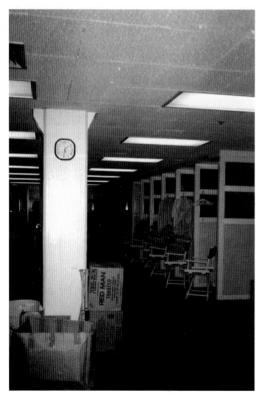

This rare public photograph shows the mid-1990s Yankees clubhouse after the season as players' belongings are boxed up to be shipped out. The clubhouse had a number of special lockers, including the last one on the left-hand side that belonged to the late Thurmon Munson that remained unoccupied after his untimely death in 1979. The clubhouse featured a sports medicine training and rehabilitation area, the players' private lounge, the manager's office, and offices for the coaches and clubhouse staff. (Courtesy of Margaret Beirne.)

THE PIN-STRIPED LEGACY

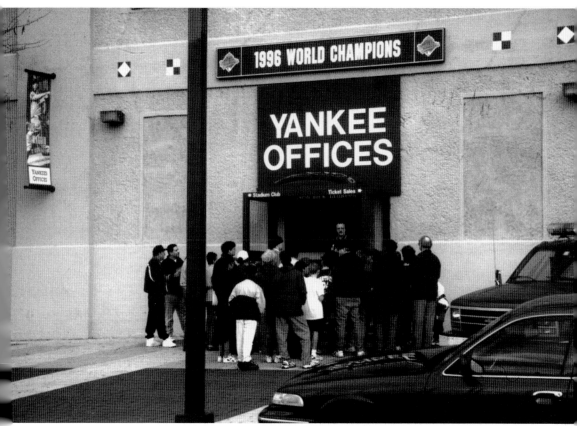

The entrance to the Yankees' executive office was on the third-base side of the stadium, on a small street called Ruppert Place. It is one of the ways players and Yankees staff entered and exited the building. (Courtesy of the Bronx County Historical Society.)

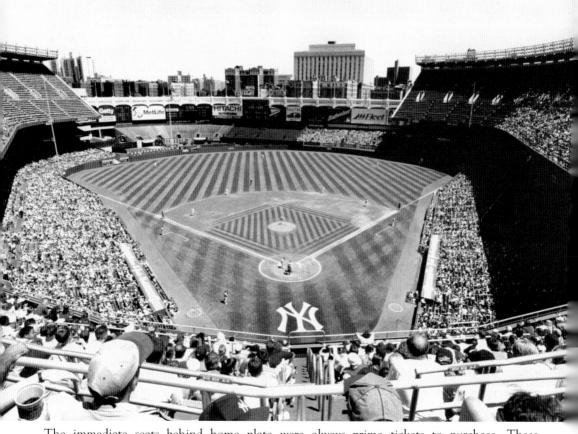

The immediate seats behind home plate were always prime tickets to purchase. These tier (upper-deck) seats give a great view of the action during the 1997 campaign. (Courtesy of Photofest.)

THE PIN-STRIPED LEGACY

After the Yankees won the 1996 World Series, the team's popularity soared and sellouts once again became a regular occurrence. If fans were lucky, they could purchase a ticket on game day, although the team's late-1990s and early-21st-century success made this much more difficult than in the 1980s. (Courtesy of Photofest.)

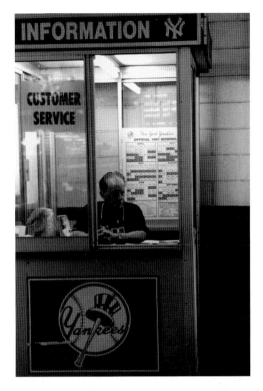

The electric atmosphere along 161st Street and River Avenue was a large part of experiencing a Yankees game. If tickets were sold out, fans could watch the game in any of a number of bars that surrounded the stadium. Souvenirs were available on the way into the game. (Courtesy of Photofest.)

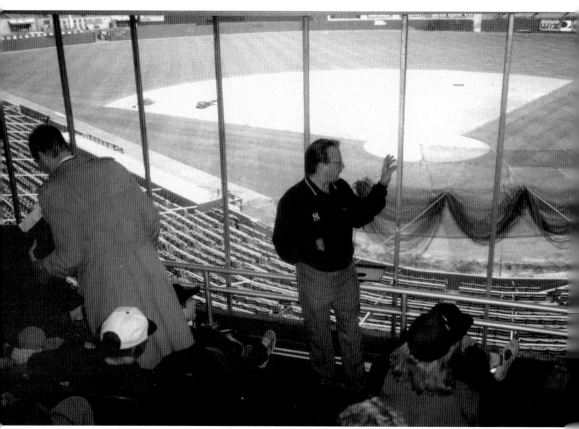

During the 1980s, Yankees officials began giving informal stadium tours. Then, under the direction of the Bronx County Historical Society, a permanent tour script was developed and regular tours soon became open to the public. Anthony Morante, New York Yankees historian and stadium tour director, has operated these tours for over two decades. (Courtesy of Margaret Beirne.)

THE PIN-STRIPED LEGACY

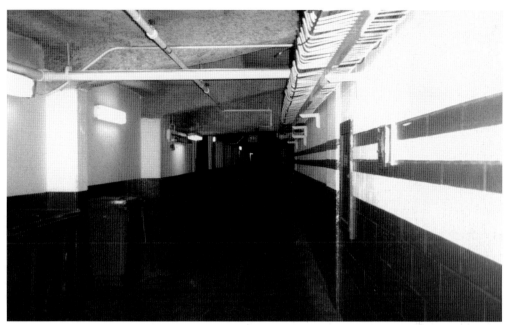

The stadium contained numerous underground corridors that provided discreet passage for players to move around the stadium without having to interact with fans. Also, the underground areas contained rooms and offices for the grounds crew, stadium security, food and concessions, and a small police station. (Courtesy of Margaret Beirne.)

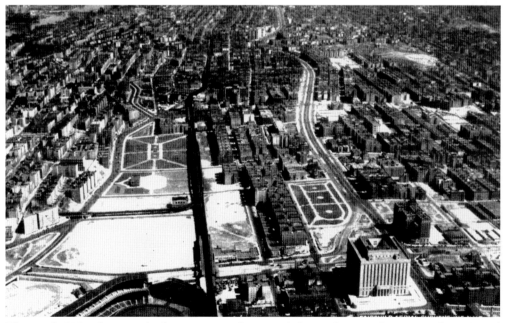

This mid-1990s photograph shows an aerial view of the stadium and its immediate Grand Concourse neighborhood after building renovations and street improvements. (Courtesy of the Bronx County Historical Society.)

An overhead view of center field captures Monument Park as well as the left-center-field bleachers. The stadium's numerous scoreboards and advertisements stood above the bleachers, along with a replica of the stadium's old frieze. (Courtesy of the Bronx County Historical Society.)

Players perform outfield pregame warm-ups prior to a late-1990s game with the Texas Rangers. As per tradition, players warmed up closest to their dugouts, with the home team stretching on the right field line and the visitors on the left. (Courtesy of Margaret Beirne.)

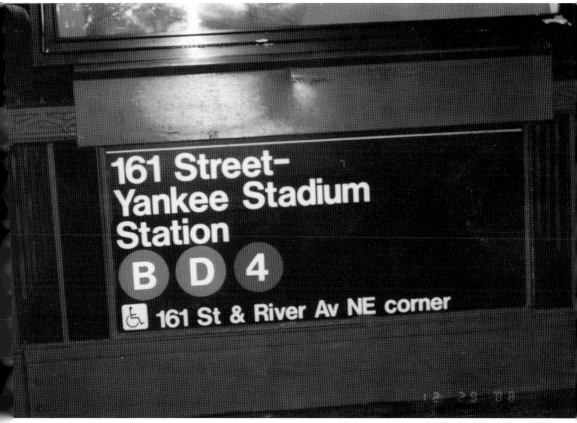

The 161st Street train station is one of the busiest during the season, and many fans utilize New York City's excellent public transportation system to get to games. Fans can access the stadium from the Bronx and from either side of Manhattan, with the D and B trains providing west side connections and the No. 4 to the east side. (Courtesy of Margaret Beirne.)

These windows were usually filled on game days, with fans purchasing walk-up tickets and picking up preordered tickets at the will call. This south side ticket window was also a common meeting place for fans to congregate before entering the ballpark. (Courtesy of Margaret Beirne.)

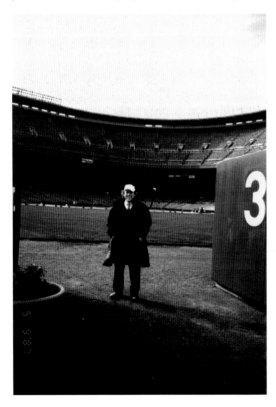

Dr. Gary Hermalyn, coauthor, stands in the bullpen doors during a late-1990s tour of the facility. (Courtesy of Margaret Beirne.)

THE PIN-STRIPED LEGACY

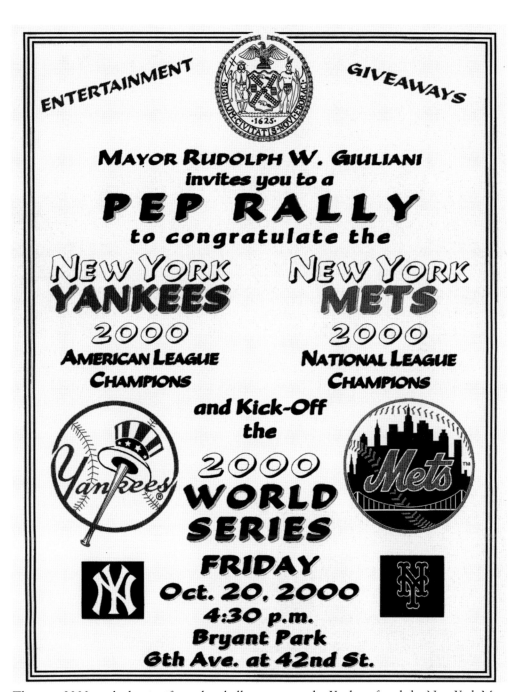

The year 2000 marked a significant baseball moment as the Yankees faced the New York Mets in the first subway series since the 1950s. The series reignited the bragging rights rivalry as the Yankees defeated the Mets in five games, with Derek Jeter earning MVP honors. (Courtesy of the Bronx County Historical Society.)

The Yankees made vast improvements to their Tampa spring training facility over the years. The compound features a playing field with identical dimensions of the stadium (newly named Steinbrenner Field), an 11,000-seat stadium, and its own Monument Park. Here manager Joe Torre and batting coach Don Mattingly answer questions from the media during the 2004 season. (Courtesy of Margaret Beirne.)

In 2004, the Yankees traded popular second baseman Alfonso Soriano for perennial all-star shortstop Alex Rodriguez. As Rodriguez switched to third base, former Yankees third baseman Graig Nettles came to the Tampa spring training complex to assist in Rodriguez's transition. "A-Rod" has continued his MVP-level play in pinstripes. (Courtesy of Margaret Beirne.)

Andy Pettitte, a dependable and consistent left-handed starter, won four World Series titles in his first stint with the club. He later returned to the team in 2006. (Courtesy of Margaret Beirne.)

THE PIN-STRIPED LEGACY

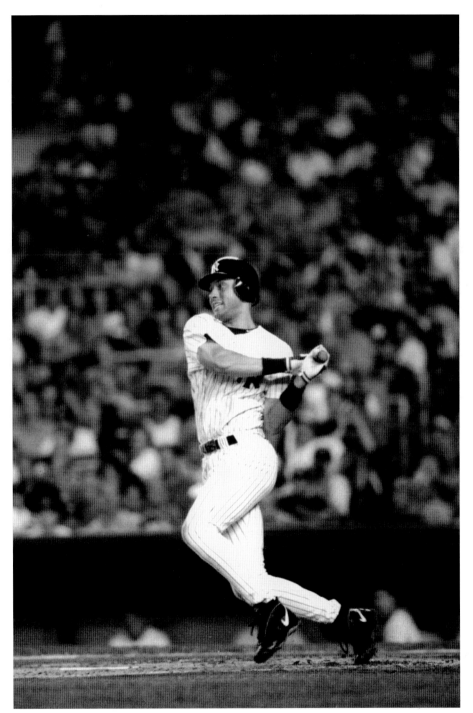

Shortstop Derek Jeter was named team captain in 2003, one of the highest honors any Yankee can receive. He is known for his acrobatic plays and his clutch play-off performances. He, along with catcher Jorge Posada and pitcher Mariano Rivera, formed the core of the late-1990s and early-21st-century dynasty. (Courtesy of Photofest.)

During the 2005 season, the Yankees announced plans to build a new Yankee Stadium in Macombs Dam Park, on the north side of 161st Street. Amid community opposition, the City of New York approved the plans, and the new stadium broke ground on August 16, 2006. (Courtesy of the Bronx County Historical Society.)

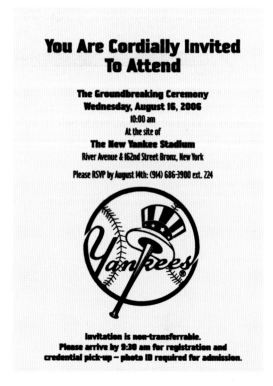

New York mayor Michael Bloomberg was instrumental in pursuing numerous stadium redevelopment projects, including wooing the Olympics and building a new West Side Manhattan football stadium. Although those plans failed, he was successful in advocating for the new Yankee Stadium and the Mets' new Citi Field. (Courtesy of Anthony C. Greene.)

The groundbreaking ceremony was a combination of pomp and revelry. Upon entering the site, guests were welcomed by this mobile Yankee Music Box, playing baseball-related music. (Courtesy of Anthony C. Greene.)

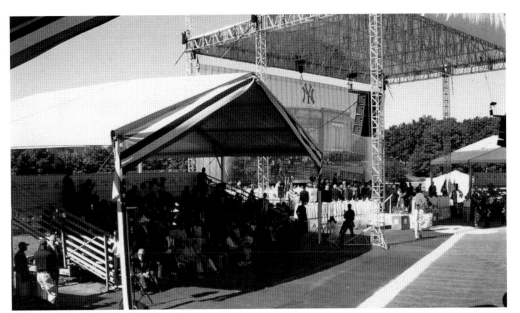

Guests were seated in stands around an artificial baseball diamond that faced a dais for VIPs and dignitaries only. Popcorn, peanuts, and water were served to guests on this hot August day. (Courtesy of Anthony C. Greene.)

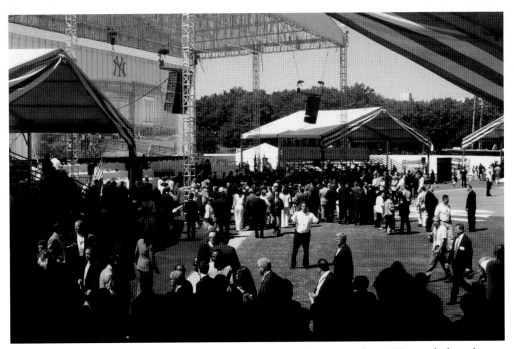

After a few hours of speeches and ceremony, the crowd converged as VIPs, including former Yankees principal owner George M. Steinbrenner, Bronx borough president Adolfo Carrion, and Gov. George Pataki, dug ceremonial shovels into the ground to signify the beginning of construction. (Courtesy of Anthony C. Greene.)

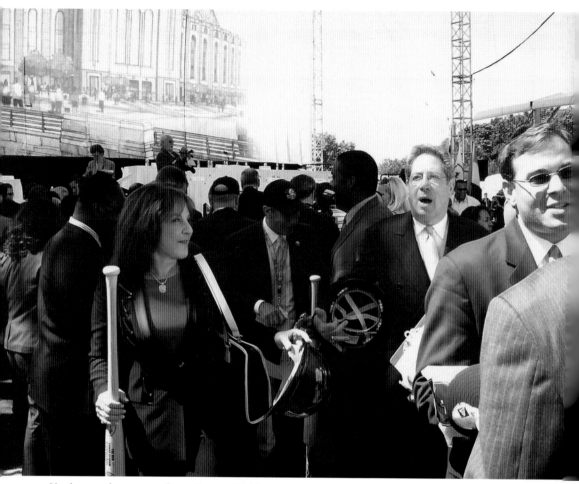

Yankees radio personalities Suzyn Waldman and John Sterling were on hand and assisted in hosting the event. (Courtesy of Anthony C. Greene.)

THE PIN-STRIPED LEGACY

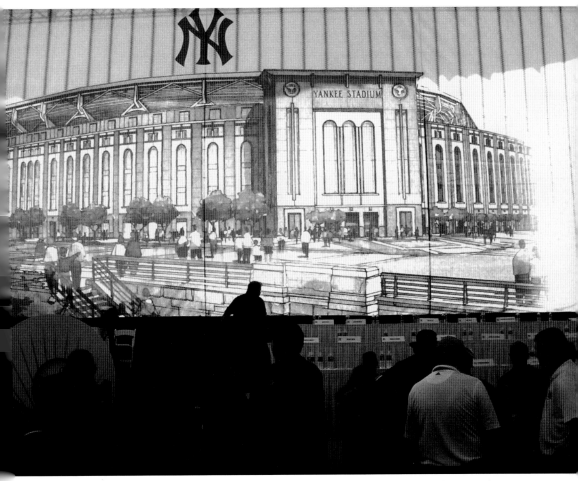

The architectural rendition of the new Yankee Stadium hung high above the VIP dais as a prelude to what was soon to come on the site. (Courtesy of Anthony C. Greene.)

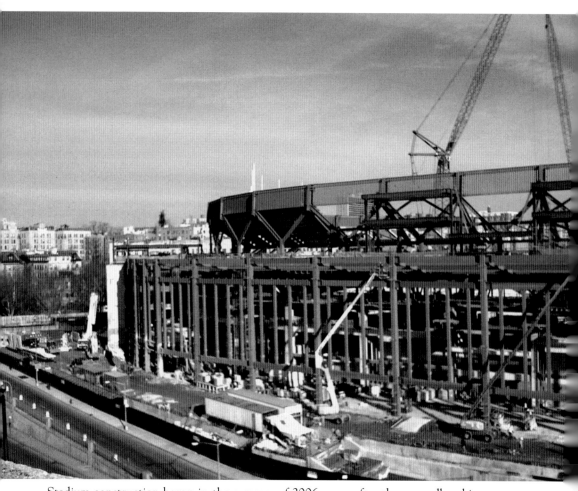

Stadium construction began in the summer of 2006, soon after the groundbreaking ceremony. This concluded a process of converting Macombs Dam Park (including its athletic fields and track), prepping the construction site, and beginning to lay the foundation. (Courtesy of Anthony C. Greene.)

THE PIN-STRIPED LEGACY

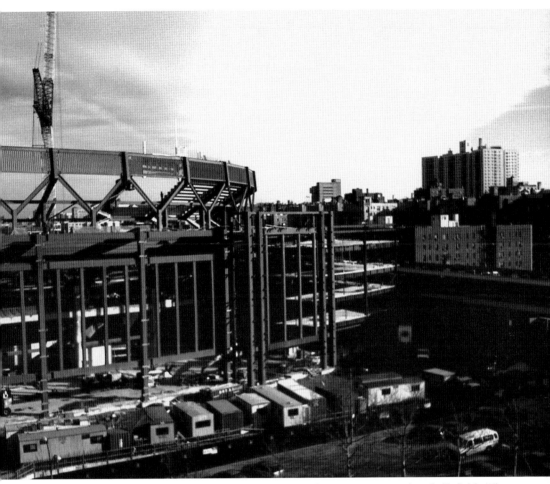

The new stadium construction project is much larger than just a mere baseball field. The stadium will have numerous restaurants, a museum, offices, and thousands of square feet of nonbaseball-related activities. In all, the new stadium is 500,000 square feet larger than its predecessor. (Courtesy of Anthony C. Greene.)

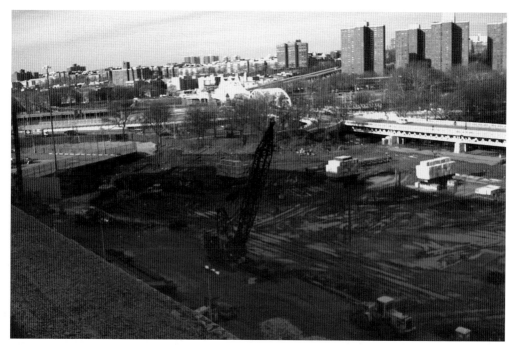

The Yankee Stadium redevelopment project was a vast undertaking. The removal of Macombs Dam Park took 12 acres of much-needed green space away from local residents, a situation that was remedied with the addition of over 27 acres of new park space. This overhead view shows the construction of the new Macombs Dam Park, which is going to be on the roof of a new parking garage. (Courtesy of Anthony C. Greene.)

This photograph shows the southern construction zone, where improvements to the Major Deegan off-ramps, the transition of the 155th Street parking garage into a greenway, and the construction of a new Metro North commuter rail station are being completed. (Courtesy of Anthony C. Greene.)

THE PIN-STRIPED LEGACY

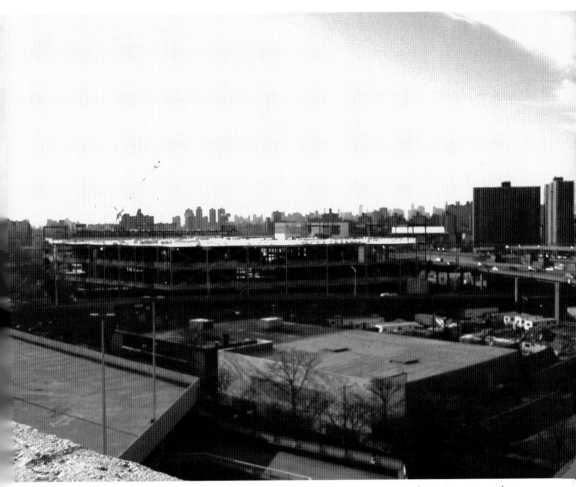

A major part of the project was the building of the Gateway Center that is going to bring much-needed shops, parking, and restaurants to the neighborhood surrounding the stadium. (Courtesy of Anthony C. Greene.)

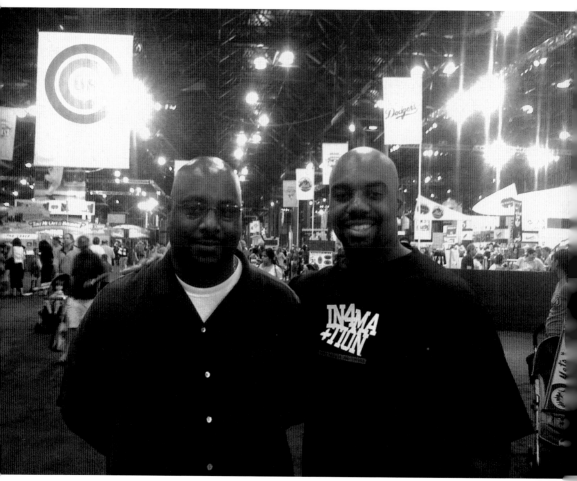

The Major League Baseball FanFest at the Jacob Javits Convention Center in Manhattan was a major part of the 2008 All-Star Game attractions. The fan-friendly event featured numerous exhibitions, live television shows, autograph sessions, and interactive attractions. Here coauthor Anthony C. Greene poses with his father, Christopher Greene. (Courtesy of Anthony C. Greene.)

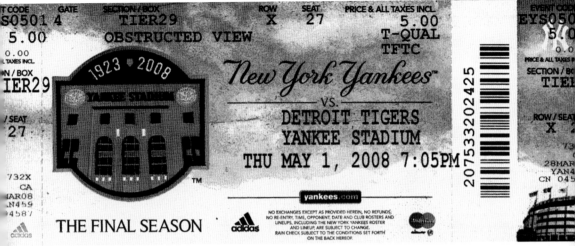

During the final season, the Yankees offered numerous discount ticket promotions that enabled many fans to watch the games live, in "the House That Ruth Built" for the final time. This ticket stub is from the very popular $5 ticket promotion that discounted bleacher and upper-deck tier seats to $5. (Courtesy of Margaret Beirne.)

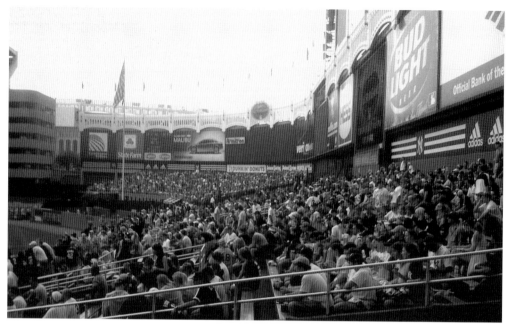

The right field bleachers, home of the "Bleacher Creatures" and their famous chants during home games, become that much more lively during Yankees–Red Sox tilts. Here the bleacher fans watch the action on July 4, 2008. (Courtesy of Anthony C. Greene.)

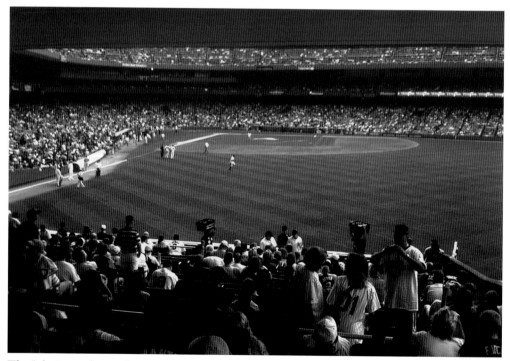

The July 4 crowd roars during a very exciting game, although the Yankees came out on the losing end of a 6-4 score. (Courtesy of Anthony C. Greene.)

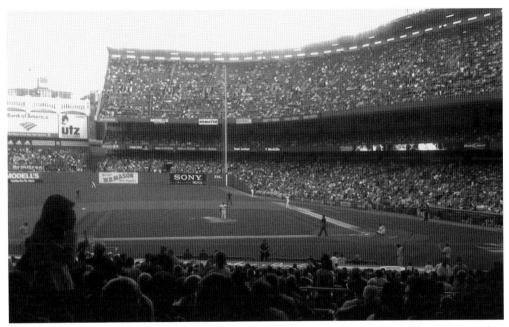

The Yankees and Padres met in a rematch of the 1998 World Series during 2008 interleague play. Pitcher Darrell Rasner outdueled Padres ace Jake Peavy for an 8-5 Yankees victory. (Courtesy of Anthony C. Greene.)

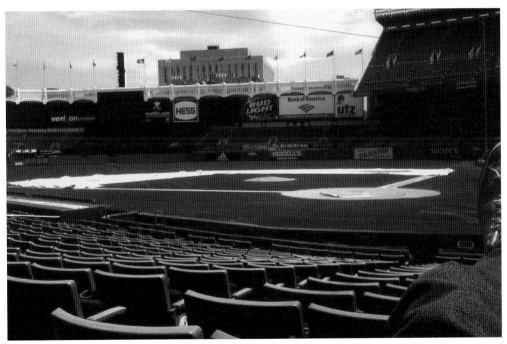

Although the Yankees did not make the play-offs, the final season marked an important opportunity to appreciate the beauty and majesty of the old ballpark in the Bronx. Here is a late summer view of an empty stadium prior to pregame warm-ups. (Courtesy of Anthony C. Greene.)

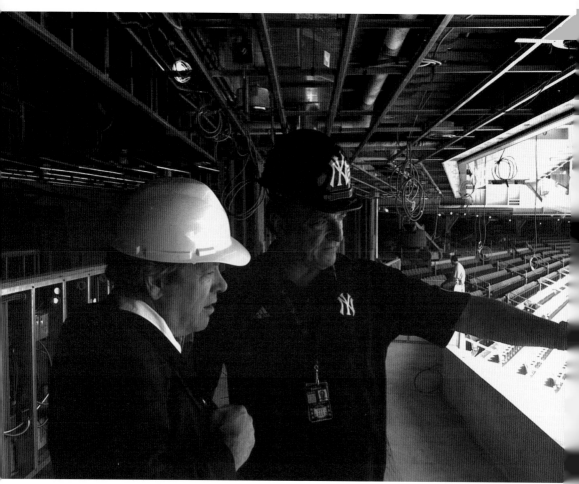

Yankee Stadium historian and stadium tour director Anthony Morante describes the new Yankee Stadium dimensions and amenities to Dr. Gary Hermalyn. Morante is truly a walking museum of Yankees knowledge and is actively involved in developing tours and programs for the new Yankee Stadium. He is one of the world's foremost authorities on the Yankees and the sport of baseball. (Courtesy of Anthony C. Greene.)

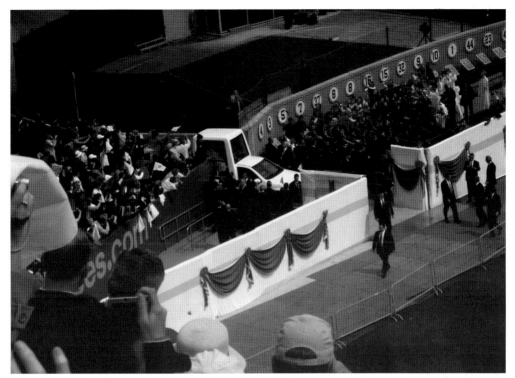

Yankee Stadium had the distinct honor of hosting three different papal masses from three different popes. Here Pope Benedict arrives in his Popemobile near Monument Park, en route to the infield stage where he officiated over a historic mass to a packed audience. (Courtesy of Robert Lorfink.)

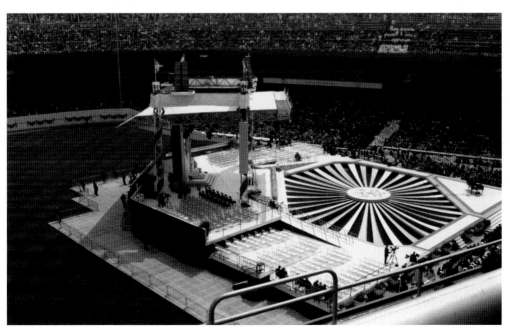

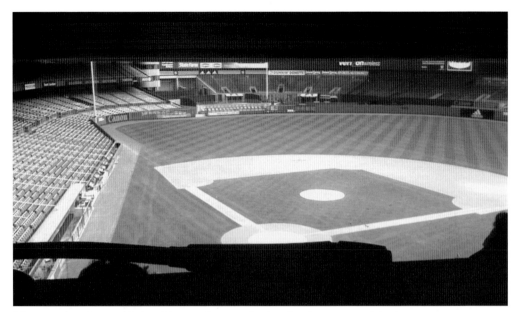

The press box, located behind home plate on the loge level, was one of the best vantage points to watch a game. The press box accommodated members of the print media and broadcasters and was where Bob Sheppard, "the Voice of Yankee Stadium," performed his duties as public address announcer for 57 seasons. (Courtesy of Anthony C. Greene.)

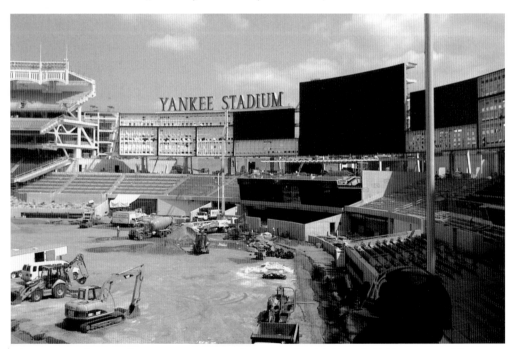

The new Yankee Stadium was constructed during the 2007 and 2008 seasons. This view looking at right field shows the installation of seating and field components. (Courtesy of Anthony C. Greene.)

THE PIN-STRIPED LEGACY

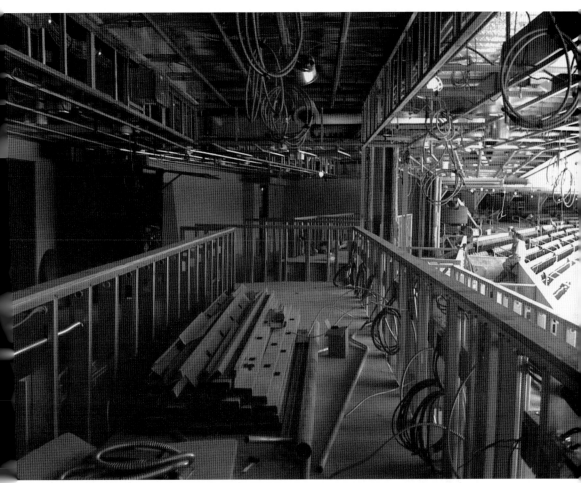

The new stadium has maintained many Yankees traditions, while adding modern amenities that many new ballparks feature. The views and sight lines have been greatly improved, and the press box (pictured here) will be updated to the highest possible standards. (Courtesy of Anthony C. Greene.)

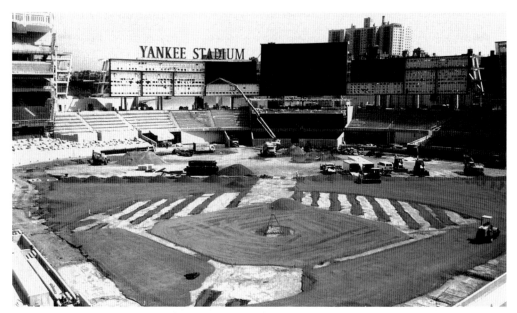

The best view will still be from behind home plate, as evidenced by this construction photograph. Here one can see the new scoreboard and video replay board, along with the center field bleachers, the future site of Monument Park, and the center field restaurant and entertainment areas. (Courtesy of Anthony C. Greene.)

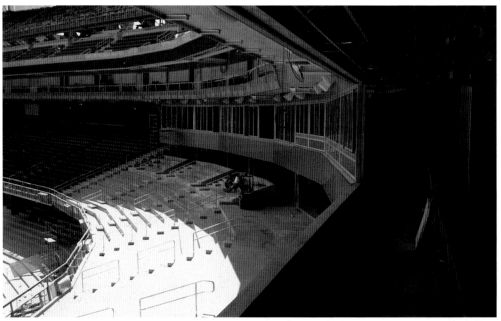

Luxury seating and accommodations are a major difference between the old and new Yankee Stadiums. The new stadium will feature dozens of luxury areas, restaurants, and both indoor and outdoor luxury suites for both in-season and postseason activities. (Courtesy of Anthony C. Greene.)

The new stadium was proudly built by many construction workers who hailed from New York City and the Bronx in particular. In addition, the site is supposed to provide much-needed service-industry positions, as the new stadium will feature year-round dining and entertainment. (Courtesy of Anthony C. Greene.)

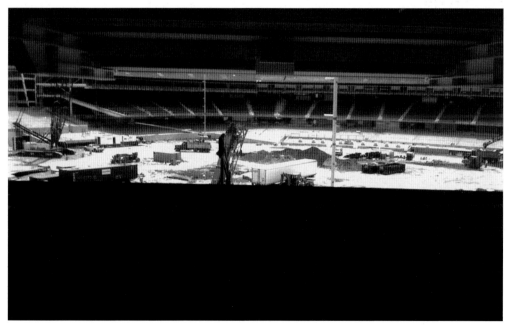

The new stadium features great concourse field views. When fans leave their seats they do not have to miss any action as one can still see the playing field from the concourses. (Courtesy of Anthony C. Greene.)

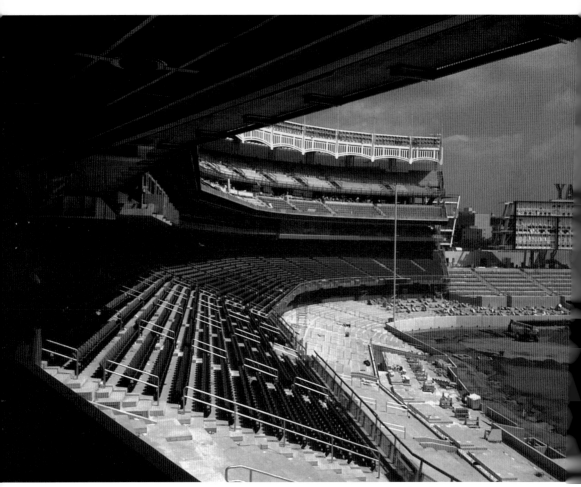

This picture shows the third-base stands, featuring new seating levels whose orientation has been changed to provide for better views of the entire playing field. (Courtesy of Anthony C. Greene.)

THE PIN-STRIPED LEGACY

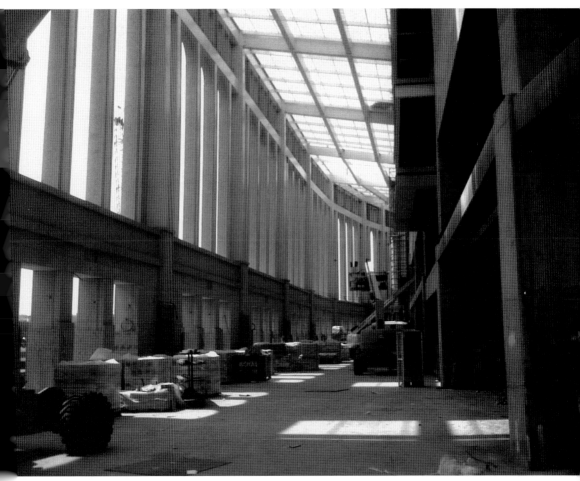

This construction photograph shows the "Great Hall," an open-air concourse that leads fans from the 161st Street entrance up the first-base line to restaurants and the new Yankees museum. The new stadium has an additional 500,000 square feet of building space to provide much-needed room for fans to move into different areas. (Courtesy of Anthony C. Greene.)

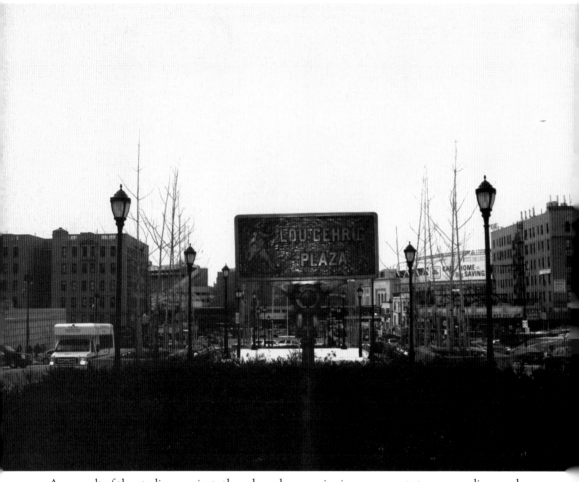

As a result of the stadium project, there have been major improvements to surrounding roadways and stadium access points. One of the most visible improvements has been that of the area east of the stadium along the 161st Street corridor. The redesigning of Lou Gehrig Plaza, improvement to the Grand Concourse transverse road and tunnel, and planting of new trees along the Grand Concourse are among the most noticeable. (Courtesy of Joshua Amata.)

THE PIN-STRIPED LEGACY

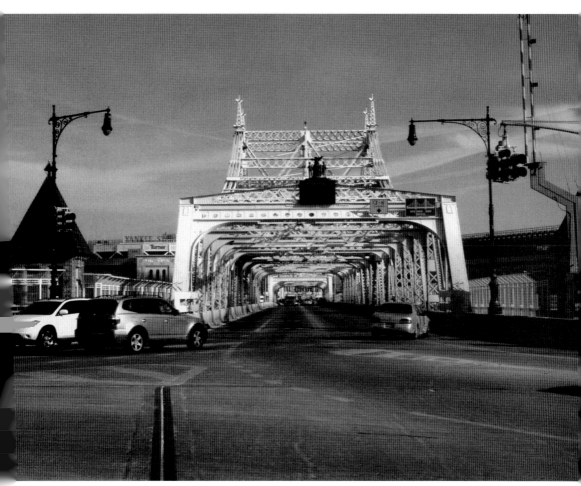

Over the years, the Macombs Dam Bridge has brought millions of fans to the stadium. After undergoing numerous renovations, it remains one of the most aesthetically pleasing of the 14 Harlem River bridge crossings. (Courtesy of Joshua Amata.)

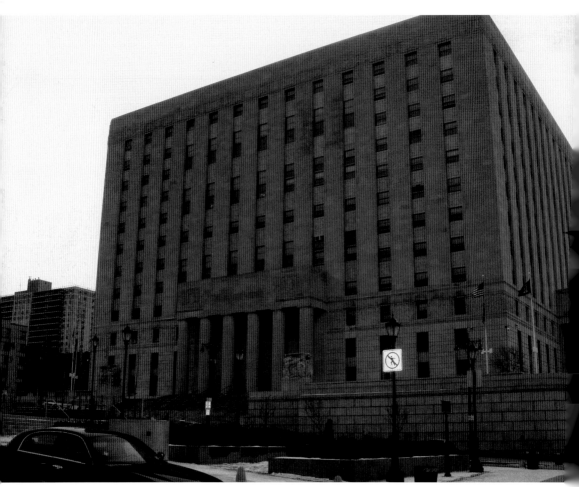

The Bronx County Courthouse has also undergone recent exterior improvements as the surrounding community has prepared for the new stadium's April 2009 opening. The restoration of this historic building was important as it stands as one of the borough's most important buildings. (Courtesy of Joshua Amata.)

THE PIN-STRIPED LEGACY

The new stadium project has impacted the surrounding businesses and transportation. New bars and restaurants have appeared on 161st Street and along River Avenue, and longtime restaurants like McDonald's have been renovated in preparation for the new Yankee Stadium. (Courtesy of Joshua Amata.)

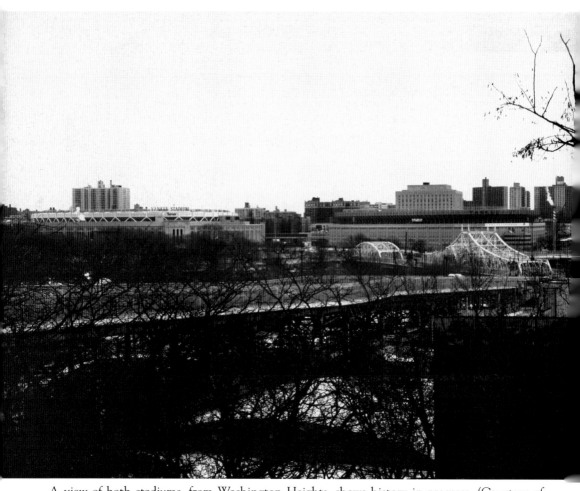

A view of both stadiums, from Washington Heights, shows history in progress. (Courtesy of Joshua Amata.)

THE PIN-STRIPED LEGACY

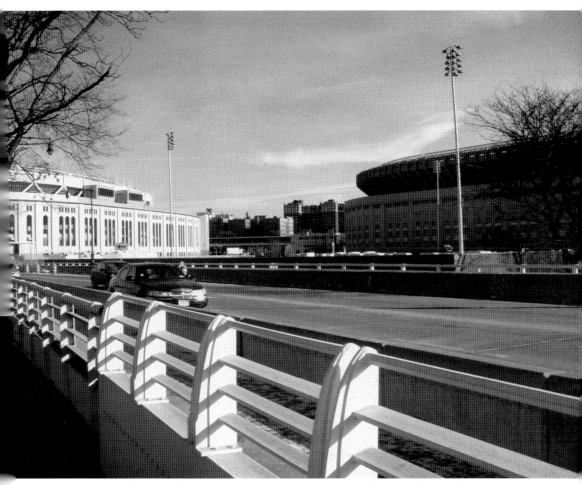

This view from the Macombs Dam Bridge depicts the new and old Yankee Stadiums prior to opening day 2009. (Courtesy of Joshua Amata.)

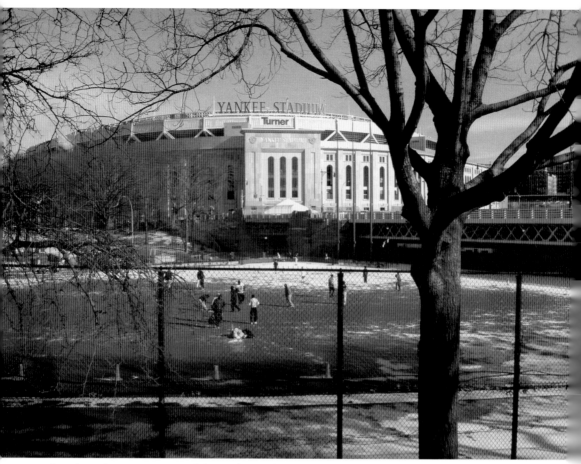

Local residents enjoy one of the parks in the shadow of the new stadium. As a new chapter in Yankees and Bronx history begins, many questions remain about land usage, community access, and ultimately, will the new Yankee Stadium prove to be anything like its predecessor? Only time and history will tell. (Courtesy of Joshua Amata.)

THE PIN-STRIPED LEGACY

ABOUT THE BRONX COUNTY HISTORICAL SOCIETY

The Bronx County Historical Society was founded in 1955 for the purpose of promoting knowledge, interest, and scholarly research in the Bronx and New York City. The society administers the Museum of Bronx History, Edgar Allan Poe Cottage, a research library, and the Bronx County Archives. The society also partners with community-based groups and research institutions on major initiatives including the Bronx African-American History Project with Fordham University and numerous Teaching American History Grant projects sponsored by the New York City Department of Education. The Bronx County Historical Society is a major publisher of books, journals, monographs, and newsletters and produces original educational programming that features neighborhood walking tours, lectures, courses, commemorations, teacher training, and radio and cable television programs. The society is committed to furthering the arts and contributing to the sense of pride in Bronx communities.

ACROSS AMERICA, PEOPLE ARE DISCOVERING
SOMETHING WONDERFUL. *THEIR HERITAGE.*

Arcadia Publishing is the leading local history publisher in the United States. With more than 3,000 titles in print and hundreds of new titles released every year, Arcadia has extensive specialized experience chronicling the history of communities and celebrating America's hidden stories, bringing to life the people, places, and events from the past. To discover the history of other communities across the nation, please visit:

www.arcadiapublishing.com

Customized search tools allow you to find regional history books about the town where you grew up, the cities where your friends and family live, the town where your parents met, or even that retirement spot you've been dreaming about.